IMAGES
of America

WOODLEY AND
ITS RESIDENTS

IMAGES
of America

WOODLEY AND ITS RESIDENTS

To Gigi
With all good wishes
5/7/09

Al Kilborne
with a foreword by Walter Isaacson

ARCADIA
PUBLISHING

Published by Arcadia Publishing
Charleston SC, Chicago IL, Portsmouth NH, San Francisco CA

Printed in the United States of America

Library of Congress Catalog Card Number: 2007931948

For all general information contact Arcadia Publishing at:
Telephone 843-853-2070
Fax 843-853-0044
E-mail sales@arcadiapublishing.com
For customer service and orders:
Toll-Free 1-888-313-2665

Visit us on the Internet at www.arcadiapublishing.com

This book is dedicated to the members of the Woodley Society, past, present, and future, who have unearthed so many long-buried pieces of the extraordinary story of Woodley and its residents.

CONTENTS

ACKNOWLEDGMENTS

Many people have made this book possible; a full listing would be impossible, but let me single out a few of those whose help has been particularly valuable. First there are Sheree White, Robert Powers, Witt Farquhar, and my editor, Mary House Singh, whose support and enthusiasm were constants throughout so much of the research. Reginald Washington and Connie Potter at the National Archives (NA) and Jeffrey Bridgers and Abby Yokelson at the Library of Congress (LOC) helped at crucial moments. Linda Johnson provided technical assistance and brilliance of design at virtually every juncture. Marjorie Hunt and Stephen Spector both contributed to a documentary version of the story of Woodley. Local historians Jane Freundel Levey, Carlton Fletcher, and the late Louise Mann-Kenney pointed us in right directions numerous times. Historians Gar Alperovitz, Michael Beschloss, Walter Isaacson, Anthony Pitch, Michael Kazin, Cliff Sloan, and Ira Berlin were generous with their time and advice. Louise Webb and William "Dump" Butler provided us with unforgettable recollections of what it was like to work in the tobacco fields of southern Maryland before mechanization.

But the lion's share of the credit goes to the students who again and again provided the inspiration and the dedication to bring a series of names back to life. Special kudos go to Stelios Xenakis for his research on Benjamin Stoddert; Alex Yergin, Andrew Fieldhouse, and Peter Gardner for their work on Philip Barton Key; Adam Buresh for his work on Martin van Buren; Matthew Lesser for his work on Robert Walker; Peter Miller and Betsy Isaacson for their work on Lorenzo Thomas; Mimi Taskier, Clayton Davis, Douglas Groat, Catie English, Sam Lewis, Kendra Mitchell, Rebecca Slotkin, and Catherine Slowick for their work on Lucy Berry; Tess Dearing and Alix McKenna for their transatlantic work on Woodley Lodge; Thea Nelson, Robert Eccles, Jason Livingood, Robert Shanklin, Will McAllister, Alex DeLeon, Douglas Groat, Tom Moumouras, Nick Greenfield, Chris Danello, and Julian Spector for extensive research on a variety of different residents and topics; Charles Fishl for the professionalism of his camerawork, and finally, Connor Renfrow for both his research and the creation of a Woodley Web site.

Thanks, too, are in order for the following descendants of many of the residents who have supported us with their interest, their archives, and their memories: Sarah Kettler (Ninian Beall), Philip Barton Key, Missy Van Buren, Long Ellis, Sally Ellis, Lucia Ellis Uihlein, Lamar Leland, Sarah Stimson, and Beatrice Berle Meyerson.

And finally, there is my wife, Elsie Walker, who bore with me through all the ups and downs of finishing this book.

FOREWORD

Woodley is a house of great historic resonance; it has been home to more prominent residents than any other private house in the country. It is also a place of distinguished teaching; since 1952, it has served as the main building of the Maret School. Thus, it is fitting that Woodley itself has become a tool for historical teaching. Students at Maret, under the tutelage and inspiration of their teacher Al Kilborne, have been experiencing first-hand the exhilaration and rigors of archival research by delving into the mansion's two centuries of history. By studying the procession of fascinating people who have lived at Woodley, the students have learned that history is not something abstract but is, instead, the interwoven narratives of real people, ranging from aristocrats to slaves. They have also learned that historical inquiry, like much of what we do in our lives and careers, is done best when it is a collaborative, teamwork effort. And for us, the readers of this delightful volume, we can experience the double pleasure of savoring the tales of a great historic home while also appreciating the joyful experience of the students who provided the research.

Al Kilborne was especially qualified to serve as the guide and author of this book. A man of quiet enthusiasm and questing intellectual honesty, he naturally conveys why history is fascinating, enriching, and important. As a child, he lived in a New England house that is now a historic house museum, and he was a decorated combat veteran of the Vietnam War. He also has a great sense of fun and adventure; he interrupted his college years to join the rodeo circuit, a career cut short (thankfully for those of us who are glad he became a history teacher) when he was stomped by a bull named "Chopper" in Madison Square Garden.

In my years of writing history, I have repeatedly run across Woodley. It was the longtime residence of the seminal wise man of bipartisan American statecraft, Henry Stimson, who was twice secretary of war (under William Howard Taft and then under Franklin Roosevelt and Harry Truman) and also secretary of state (under Herbert Hoover). When Woodley was rented by Adolph Berle, a member of Roosevelt's brain trust, Albert Einstein attended what must have been a very brainy reception there, and on another occasion, Whittaker Chambers came by to warn that Alger Hiss was a Soviet spy.

All of this goes to show, I hope, that this book is about more than just a beautiful Federal-style mansion. It is brought to life by the people—presidents and statesmen, philosophers and financiers, generals and slaves—who lived and worked there. It is brought to life, as well, by students over the years who unearthed the human tales and touched the personal face of history. And it is brought to life by a teacher who realizes that history is not merely something that is handed down to us by books and teachers. It is, or should be, something that each of us, in each day and generation, engages in and creates in collaboration with our fellow students, and later on with our fellow citizens.

—Walter Isaacson

Walter Isaacson, a Maret parent, is president of the Aspen Institute and is the former managing editor of Time *magazine and chairman of CNN. He is the author of* Albert Einstein: His Life and Universe, Benjamin Franklin: An American Life, Kissinger: A Biography, *and the coauthor of* The Wise Men.

One

BEFORE WOODLEY

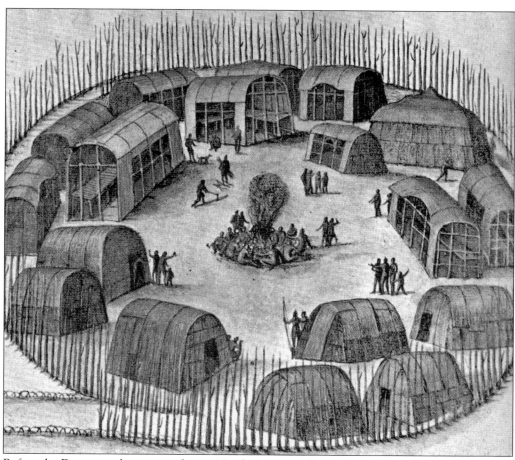

Before the Europeans began to colonize North America, the ridge on which Woodley would one day be built was part of the sustaining hinterland of the Nacotchtanks, an Algonquian-speaking people whose palisaded village was located on the far-eastern side of the Anacostia River. The Nacotchtanks were part of a confederacy whose chief rival were the Powhatans, another confederacy based farther south, whose members greeted the Jamestown settlers when they first arrived on these shores in 1607. One of the tragic consequences of European settlement was that the English began a policy of steady encroachment on Indian land. There was sporadic resistance. In 1623, at a location within 25 miles of the future site of Woodley, the Nacotchtanks ambushed and massacred a party of 20 men who had been sent from Jamestown. Whatever victories the Indians won, however, turned out to be short-lived. By the beginning of the 18th century, the Nacotchtanks, like so many other coastal Indians, had been effectively eradicated. (LOC.)

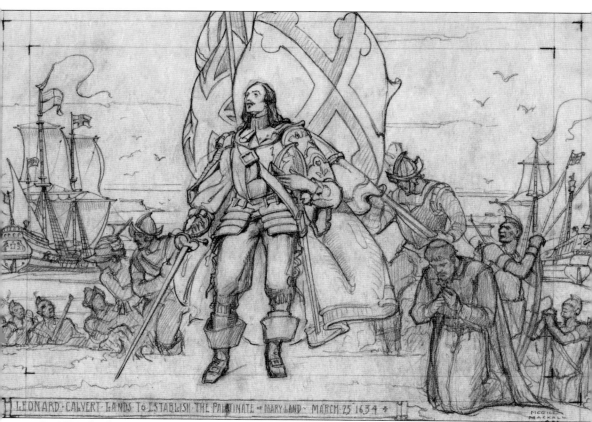

LEONARD·CALVERT·LANDS·TO·ESTABLISH·THE·PALATINATE·OF·MARYLAND·MARCH·25·1634

In 1634, the future site of Woodley was a tiny piece of a 7-million-acre land grant from King Charles I of England to Cecilius Calvert, the second Lord Baltimore. Lord Baltimore, a closet Catholic in an age when Catholics were intermittently persecuted, imagined his new province as a haven for English Catholics. In the following year, his brother, Leonard Calvert, set sail from England for the family's vast new acquisition in command of two ships, the *Hawk* and the *Ark*, and landed at a site on a tributary to the Potomac River six miles north of present-day Washington (above) and turned an idea into a reality. Nevertheless, Maryland, as they called their new domain, was not attracting a viable number of new immigrants, so in 1649, Lord Baltimore issued a Toleration Act to attract Protestants. Sadly, the Toleration Act did not extend to the Native Americans of the region. (Courtesy of the Maryland Historical Society.)

In 1703, Ninian Beall (right) bought the site of the future Woodley as part of a 795-acre tract along the Potomac River. Beall was an immigrant from Scotland who started his life in America as an indentured servant and ended up as a major landowner and merchant. In 1675, he was one of those inland farmers who took part in Bacon's Rebellion, a revolt that pitted the poor farmers of the Piedmont against the forces of Jamestown. During the final chapter of his life, Beall built a tobacco warehouse, a gristmill, and an iron foundry where Georgetown would eventually be established. (LOC.)

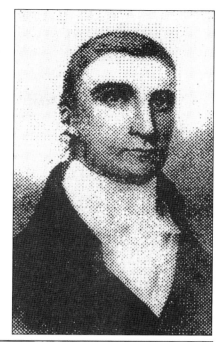

When Ninian Beall died in 1720, his estate passed to his son George, who then purchased an additional 1,380 contiguous acres. To his father's small cluster of buildings, George Beall added a ferry service, a tavern, and a "rolling house," where hogsheads (barrels) of tobacco were rolled in from outlying plantations. In 1751, the Maryland Assembly bought out Beall and a neighboring landowner and created Georgetown (above) in honor of King George II of England, the reigning monarch. Markets were soon established where factors from Scotland and Whitehaven, England, began selling a variety of commodities in exchange for small quantities of tobacco. The future Woodley was now on the outskirts of a burgeoning river port. (LOC.)

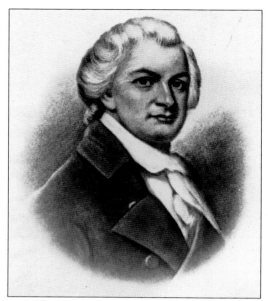
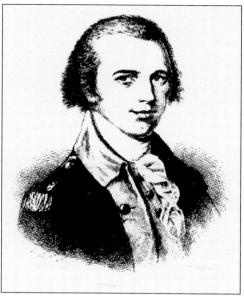

In 1783, the year the American Revolution ended, Benjamin Stoddert (left) and Uriah Forrest (right), two Revolutionary War veterans, formed a partnership that exported tobacco across the Atlantic. Stoddert was the aristocratic front man while Forrest did the nuts-and-bolts work. On March 29, 1791, Stoddert and Forrest were among a group of Georgetown landowners who met in secrecy with George Washington at Suter's Tavern (below) to strike a deal whereby land was turned over to the new Federal city in exchange for cash and future city lots. In the following year, the two men formed another partnership and purchased 1,282 acres of high ground that included the future site of Woodley. They named their new domain "Pretty Prospects" because of its panoramic vistas. (Courtesy of Louise Mann-Kenney.)

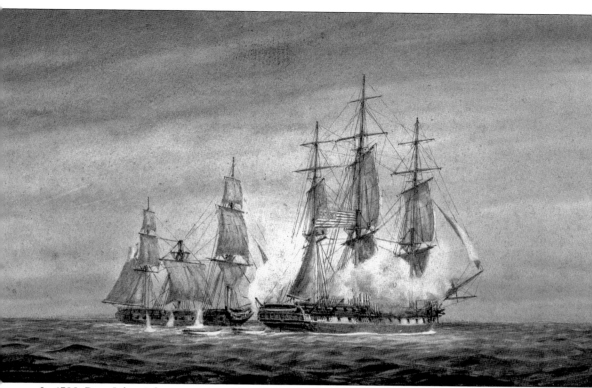

In 1798, Pres. John Adams appointed Stoddert to be the first secretary of the U.S. Navy. It turned out to be a fortuitous choice. Stoddert established six navy yards and oversaw the expansion of the American fleet in order to deal with the depredations of French privateers during what became known as the Quasi-War with France. Perhaps the most famous engagement of the war was when the 38-gun American frigate *Constellation* captured the 40-gun French frigate *L'Insergente*. During the three years of Stoddert's oversight, the Quasi War was won, and the U.S. Navy became a source of national pride. (Courtesy of the Mariners' Museum.)

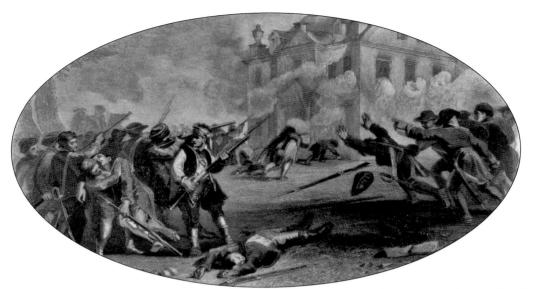

Uriah Forrest, the nuts-and-bolts partner of Benjamin Stoddert, lost a leg at the Battle of Germantown (above) in 1777. Being one-legged, however, failed to slow him down. He not only made a fortune in commerce and real estate but in 1789 married Rebecca Plater, one of the two beautiful Plater sisters, heiresses to one of the great tobacco plantations in southern Maryland. Unfortunately, in 1797, three years after buying out Stoddert, the real estate bubble of the new Federal capital burst, and Forrest was forced to sell off 250 acres to his brother-in-law, Philip Barton Key, who was married to the other beautiful Plater sister, Ann. According to Key's will, Forrest included in the deal "plate, furniture, and servants (i.e. slaves)." It was on this land that Key would one day build Woodley. (LOC.)

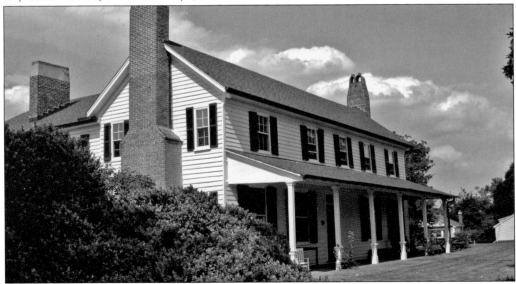

Rosedale, the unprepossessing house into which Uriah and Rebecca Forrest and their two small children moved in 1793, still stands overlooking Newark Street in northwest Washington. From the beginning, it was a magnet for prominent Federalists, George Washington, John Adams, and Philip Barton Key among them. (Maret School Archives.)

Two

THE
KEY YEARS

Philip Barton Key, the
man who built Woodley,
was born into a prominent
family of Maryland planters
living near the village of
Charleston in what is now
Cecil County. Like other
boys of the Southern gentry,
he was first educated by
tutors and then sent to
England to further his
education, a relocation that
could help to explain the
role he was later to play in
the American Revolution.
At the beginning of that
war, he mustered with his
elder brother, John Ross Key,
and a company of Maryland
patriots. But as the war
progressed, the two brothers
made opposite decisions:
John Ross Key went north to
join Washington's forces in
Boston, while Philip Barton
Key left for Philadelphia to
join a regiment of Maryland
Loyalists. (Portrait by
Dewitt Clinton Peters,
Courtesy of the Maryland
Historical Society.)

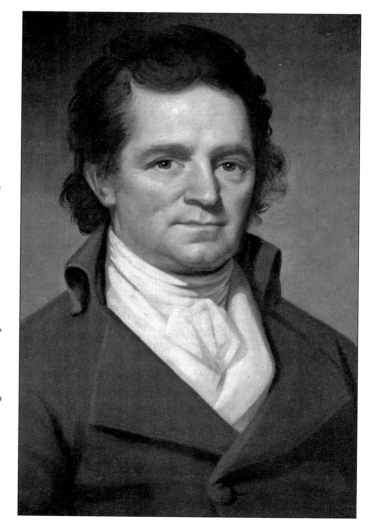

1799

John Ross Key, the brother of Philip Barton Key and father of Francis Scott Key, lacked the extraordinary good looks and intellectual horsepower of his brother and son, but he shared the family warmth, charm, and loyalty. When he, as elder son, inherited the entire family patrimony upon their father's death, he gave half of it to his younger brother Philip, which was then confiscated by a local court in 1778 (see page 18). After the Revolution and Philip's return from England, John once again gave Philip half of what he had left. Such generosity has led to speculation that the two Key brothers hedged their bets and joined opposite sides in the war to protect at least half of their family's inheritance. (Portrait by Rembrandt Peale, courtesy of the Maryland Historical Society.)

Once in Philadelphia (above), Key went about raising an infantry company of 40 men at his own expense. In all probability, he lived in relative comfort during this period. In addition to the predictable debaucheries inevitable in a wartime city, there were concerts, horse races, ice skating parties, sleighing expeditions on the Schuylkill, weekly balls for the officers in Smith's City Tavern, and raucous dinners at the Cockpit. (LOC.)

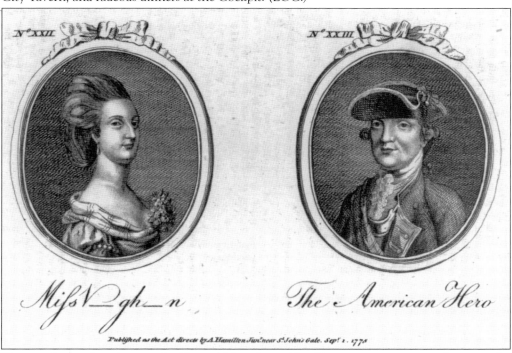

The tone had perhaps been set by General Howe himself and his mistresses, among whom was the notorious Mrs. Loring, "a flashing blonde" known throughout the ranks as "Sultana," in addition to the slightly homelier Miss V—gh—n pictured above. How much the young Lieutenant Key participated in the high life of occupied Philadelphia will have to remain a mystery. (LOC.)

Conditions 20 miles away couldn't have been more different as Washington and his army were suffering through the terrible deprivations of Valley Forge. Meanwhile, back in Maryland, a local court convicted Philip Barton Key of high treason in absentia and confiscated his land, slaves, and other properties. (LOC.)

In March 1778, Key was promoted to the rank of captain in Chalmer's regiment of Maryland Loyalists. In June, the regiment was moved out of Philadelphia and into New Jersey, where Key fought in the Battle of Monmouth (above), a bloodbath of heat and death. On the American side alone, 37 soldiers died of heat stroke. There is no record of the role Key played in the battle in which he would have fought against troops commanded by George Washington. (LOC.)

After the war, Key sailed for London. In 1784, he gained admittance to the Middle Temple of the Inns of Court, a combination law school and gentlemen's club. At a time when American law was English common law, Key's education in the Inns of Court proved to be a vital ingredient in advancing his subsequent career in the United States. He also cemented friendships with a number of powerful British aristocrats. (LOC.)

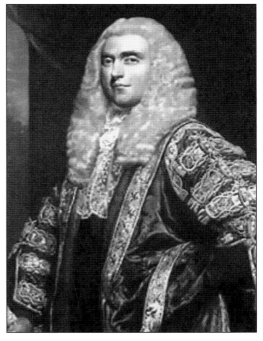

One of those aristocrats was Henry Addington (right), future Viscount of Sidmouth and prime minister for three years during the Napoleonic Wars. The wealth and influence of Addington help explain why the British government granted Key, on his departure from England, a lifetime pension equal to half his wartime salary. In addition, Key received the princely sum of 1,496 pounds in compensation for lands and properties that the State of Maryland had seized from him early in the war. (LOC.)

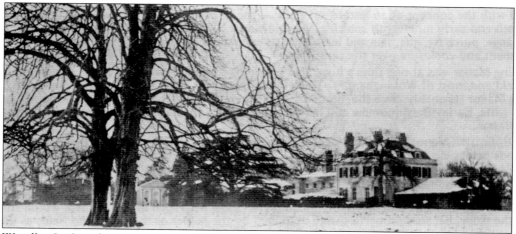

Woodley Lodge, the country seat of Henry Addington in Reading, England, was where Philip Barton Key spent time off from his studies at the Inns of Court. It was also his inspiration for the design and name of his own Woodley. ("Woodley" means "a clearing in the woods.") According to some sources, Capability Brown, the foremost landscape architect of his day, designed the English Woodley's grounds and gardens. King George III was said to have been an occasional visitor. (Courtesy of the Reading Central Library, Reading England.)

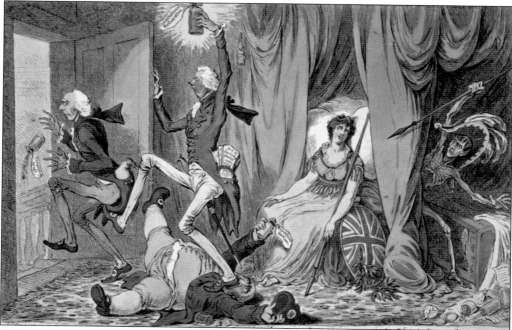

William Pitt the Younger, a contemporary of Key and Addington at the Inns of Court, was another frequent guest at the house. He, too, went on to become prime minister, which supports the likelihood that Philip Barton Key traveled in such high social circles that he established friendships with two future prime ministers and perhaps even a reigning monarch. In this cartoon, Pitt, who succeeded Addington as prime minister, is kicking Addington, who presided over the disastrous Treaty of Amiens, out the door while Britannia swoons and the specter of Napoleon as Death comes out from behind the curtain. (LOC.)

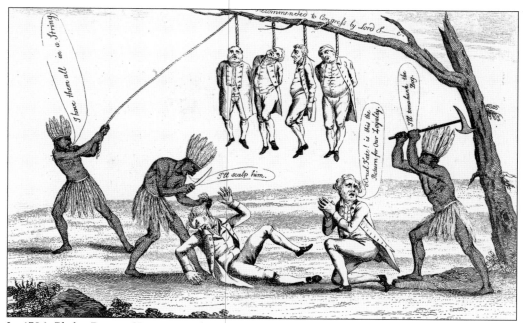

In 1786, Philip Barton Key returned to the United States. This cartoon captures the kinds of ill will that greeted most returning Loyalists. They were beaten, tarred and feathered, whipped, lynched, and otherwise treated as pariahs. Philip Barton Key was the one notable exception who managed not only to redeem his reputation but then to rise to the highest levels of post-revolutionary society and government. (LOC.)

Among the reasons that Philip Barton Key succeeded where others failed was that in 1790, he married 16-year-old Ann Plater. Despite her youth, she was already known for her beauty, brains, refinement, and dedication to French fashion. She had even been a weekend guest of the Washington's at Mount Vernon. Together the couple would dazzle social gatherings in Annapolis, where they established their first household and where Philip Barton Key set up a thriving legal practice thanks in large measure to the training he had gotten at the Inns of Court. (Courtesy of the Key family.)

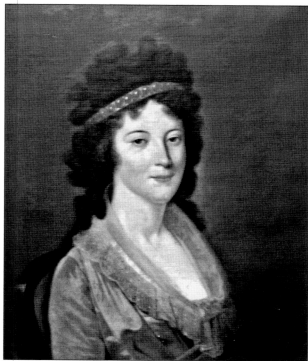

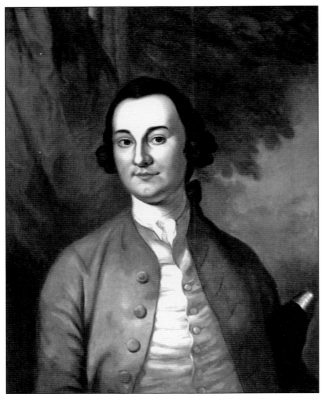

Another reason behind Key's success was his new father-in-law, George Plater III. George and Washington considered him a close friend. He was also rich; His vast holdings included 5,700 acres of prime tobacco land and 93 slaves, and he was respected. He had been a member of both the Constitutional Convention and the first Electoral College, and he would go on to become governor of Maryland. (Courtesy of the Collection of the Maryland State Archives.)

Sotterley, the Platers' tobacco plantation on the Patuxent River in St. Mary's County, Maryland, was the place where Ann Plater Key spent much of her time growing up. It also may have been the site of her marriage to Philip Barton Key. It remains one of the earliest and most charming examples of 18th-century American architecture and landscaping. (Courtesy of Sotterley Plantation.)

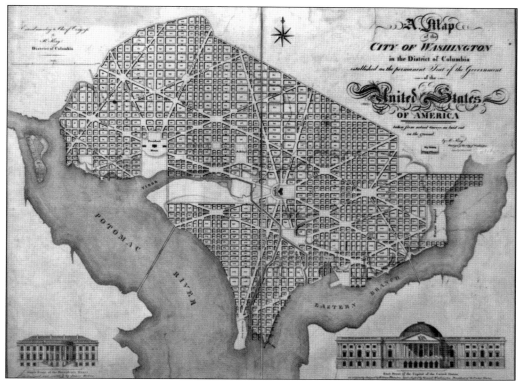

In 1790, George Washington selected a 10-by-10-mile square of territory for the national capital. Later that year, Philip Barton Key and his new bride moved to Annapolis, where he established a law office. His brilliance, together with his background in English common law, made him an instant success. Slowly, case by case, Key, the erstwhile Loyalist, who was still collecting a half pay as a British officer, was prospering and positioning himself for future political office. (LOC.)

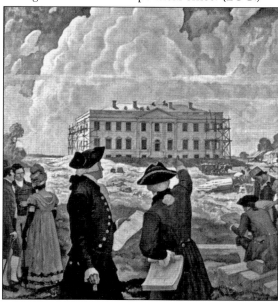

In 1792, the year construction began on the White House (right), Philip Barton Key began buying up real estate in the new Federal city. According to the register in the Office of the Recorder of Deeds, he would be involved in 32 land transactions over the next 24 years. Real estate was then the quickest path to wealth, and Key was on it at a gallop. Fortunately for Key, he was selling real estate almost as fast as he was buying it, so when the market collapsed in 1797, he didn't share the same fate as his brother-in-law Uriah Forrest. Instead, he benefited from Forrest's forced sale of 250 acres providing the site for Woodley. (LOC.)

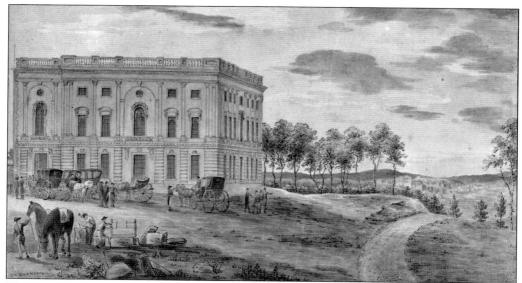

The meteoric rise of Philip Barton Key continued during the last decade of the 18th century. In 1794, he was elected to the Maryland House of Delegates. By then he was a staunch Federalist. In 1800, however, the year William Birch painted this watercolor of the newly completed north wing of the Capitol, Thomas Jefferson and the Republicans won the election from John Adams and the Federalists. As a result, Philip Barton Key's career hit a temporary setback, and he lost his seat in the Maryland House of Delegates. (LOC.)

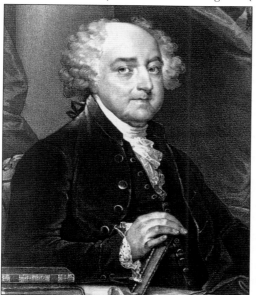 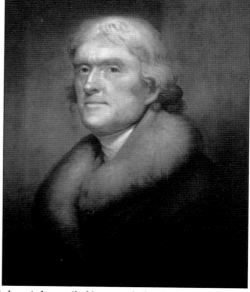

In the waning days of his administration, Pres. John Adams (left) passed the Judiciary Act of 1801, which created three new circuit courts. Because Adams appointed judges right up until the final day of his administration, they became known as the "midnight judges." One of them was Philip Barton Key, who became chief judge of the newly created Fourth Circuit. Fourteen months later, a new administration under Pres. Thomas Jefferson rescinded the Judiciary Act of 1801, and Philip Barton Key was out of a job. (LOC.)

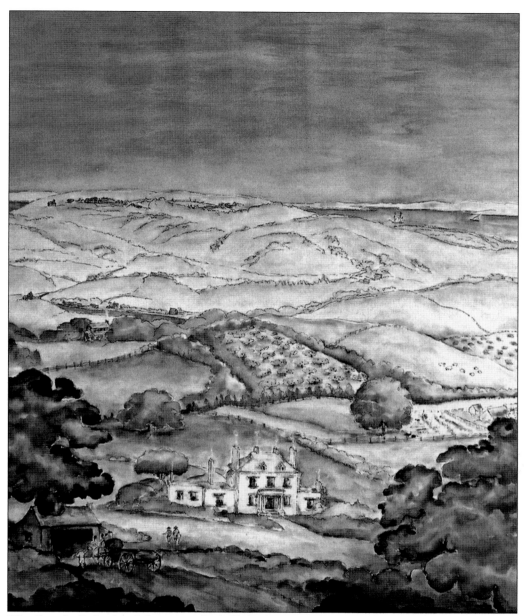

Woodley, the Federal-style house in which Philip Barton and Ann Key lived, died, and reared eight children, was completed in 1801. In all likelihood, it was built largely by skilled slave artisans. It was originally a two-story structure with six rooms downstairs and three rooms upstairs. Because the land was then cleared between the elevated site of the new house and the Potomac River, it would have commanded a breathtaking view of the incipient capital and the river traffic beyond. As a smaller version of Woodley Lodge in England, it was also a political statement, reflecting the Anglophile tastes of the Federalists rather than the neoclassical tastes of the rival Republicans. Once the Key family was installed, the house became known as a "social Mecca" for the power elite of the new Federal city, and the Keys entertained frequently in high style. ("Woodley" by Linda Johnson, courtesy of the Maloni family.)

In 1801, Philip Barton Key, Ann Plater Key, and three small daughters moved into Woodley. In addition, there would have been 10 to 15 slaves running the inside of the house and tending the surrounding fields and gardens. In the bicentennial reenactment of the arrival of the Keys at Woodley, Philip Barton Key's direct descendant of the same name, played the role of his ancestor, and Mary House Singh played the role of Ann Plater Key. (Photograph by Linda Johnson.)

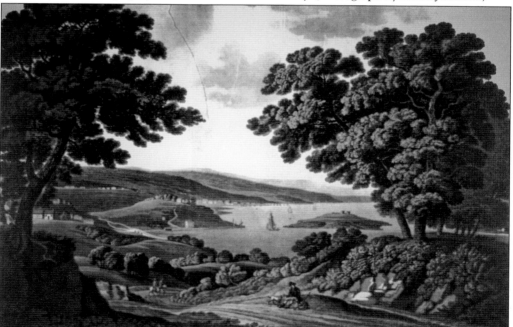

This 1801 aquatint by George Beck, sketched at a site less than a mile from Woodley looking south along the Potomac toward the new Federal capital (left center), gives a sense of how beautiful a similar view from Woodley must have been. (LOC.)

In 1804, Philip Barton Key became involved in one of the landmark judicial proceedings in American history. Samuel Chase (right), a U.S. Supreme Court justice known behind his back as "Old Bacon Face," was impeached by a highly partisan Republican House of Representatives for, among other charges, "making intemperate and inflammatory harangue[s] with intent to excite the fears and resentments of the [gallery]." The independence of the judiciary hung in the balance. Philip Barton Key was part of the defense. Perhaps the crucial moment of the trial came when John Randolph of Roanoke (below), a wild eccentric but an incomparable orator, famous for taking his hunting dogs onto the floor of the House, strode to the central dais of the Senate to give his summation for the prosecution. To his horror, he realized he had forgotten his notes. By two votes, the Senate voted to acquit, and the independence of the judiciary was assured. That night, the mood at Woodley was celebratory. (LOC.)

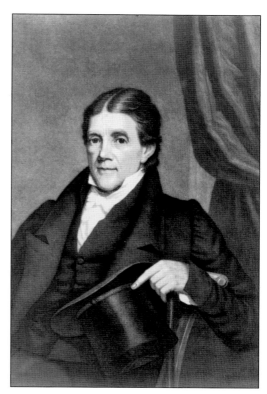

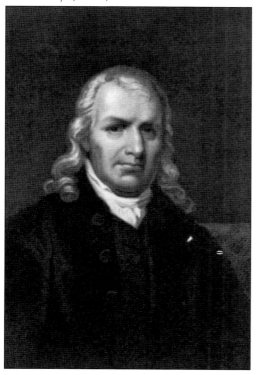

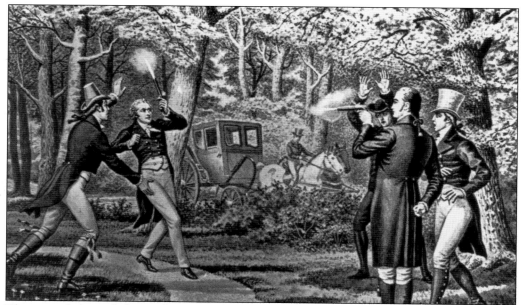

The man who presided over the trial was Aaron Burr, vice president of the United States, fresh from the killing grounds of Weehawken, New Jersey, where he had shot down Alexander Hamilton in a duel (above). Throughout the trial, Burr was under indictment in two states, prompting one wag to write, "Whereas in most courts the murderer [is] arraigned before the judge, in this court the judge [is] arraigned before the murderer." According to Burr's great-great-grandfather, he spent three weeks of the trial as a houseguest at Rosedale (see page 14). (LOC.)

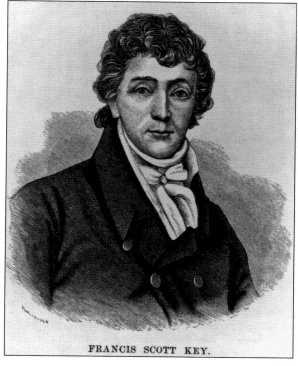

FRANCIS SCOTT KEY.

Philip Barton Key was not one who could stay out of politics for long. In 1806, he was back in the thick of it running as the Federalist candidate for the Third Congressional District of Maryland. To do so, he had to reestablish residency in Maryland. In 1806, he turned over his Georgetown law practice to his nephew and protégé Francis Scott Key (left), author of "The Star-Spangled Banner," and bought 1,000 acres of land on the Brookeville Road near what is now Norbeck. To help dispel the specter of his service as a Loyalist in the Revolution, he resigned his pension from the British Army, admitted that his service had been a terrible mistake, and went on to win the election, thereby becoming the only former Loyalist to serve in Congress. (LOC.)

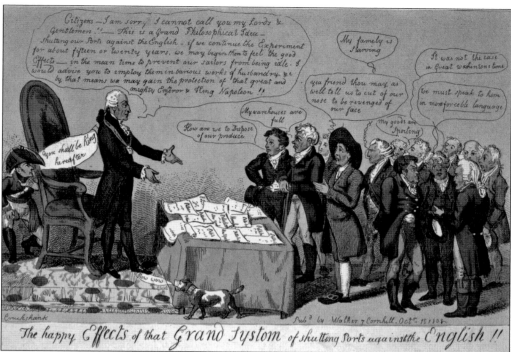

The happy Effects of that Grand System of shutting Ports against the English !!

During Philip Barton Key's first term in Congress, this country's right to trade abroad was being squeezed and violated by both the English and the French in the Napoleonic Wars. In 1807, as a measure to cut American losses and apply economic leverage against the two warring nations, Jefferson established an embargo against both nations. Its unpopularity can be seen in the political cartoon above. (LOC.)

On the right is a letter from Philip Barton Key to an unknown recipient in which he gives advice about moving slaves to Maryland and makes a few predictions such as "We shall, I think, repeal the Embargo before we rise but the House are [sic] not decided what substitute to adopt—it will not be war." He was right that the Embargo Act would be replaced (by the Non-Intercourse Act), but he was wrong when he predicted there would not be war. As to the "shameful report against [him]," the record remains tantalizingly silent. (Manuscript Room, Library of Congress.)

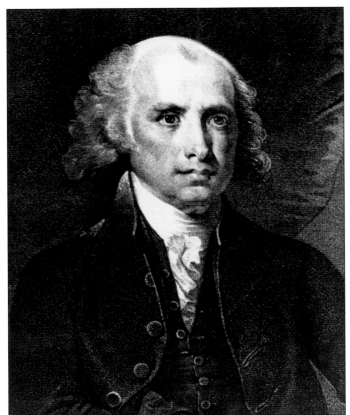

Despite the protests of Federalists and Anglophiles like Philip Barton Key, Pres. James Madison (left) finally gave in to the so-called war hawks, and the War of 1812 against Britain began. The immediate cause was British impressments, whereby British ships of war would stop American ships on the high seas and often "impress" American sailors who were mistaken for British deserters. Later in that same year, Philip Barton Key decided not to stand for a fourth term in Congress. His opposition to the war must have played a role in that decision. The war soon swept out onto the high seas. Battle scenes such as this one between the USS *Constitution* (Old Ironsides) and the HMS *Guerrier* would have made Philip Barton Key shake his head in sad disbelief. (LOC.)

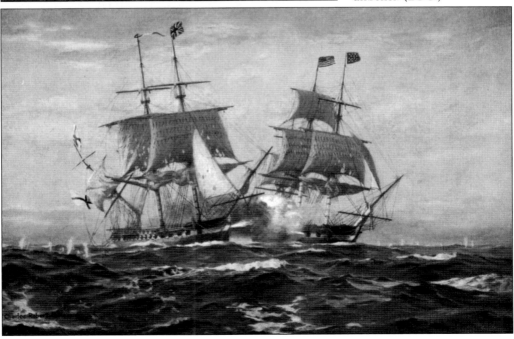

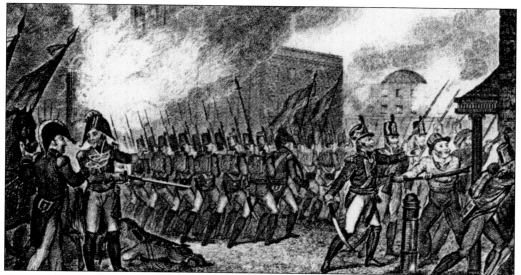

On a sweltering day in August 1814, war came to Washington. Gen. Robert Ross (the officer holding out his sword on the left in the illustration above), who had been recently selected to command the expedition by the Duke of Wellington, marched on the city from the north with 4,000 crack troops even as a mass exodus of Washington citizens fled the city. At 9:00 p.m. British forces carrying "Torches of Hell Fire" set fire to the Capitol. The White House was next. The conflagration turned night into day. From Woodley, flames hundreds of feet high could be seen gushing into the night sky and the roar of those flames was clearly audible. Meanwhile, bridges over both the Potomac and the Anacostia Rivers could be seen burning or being blown sky high by large charges of powder. (LOC.)

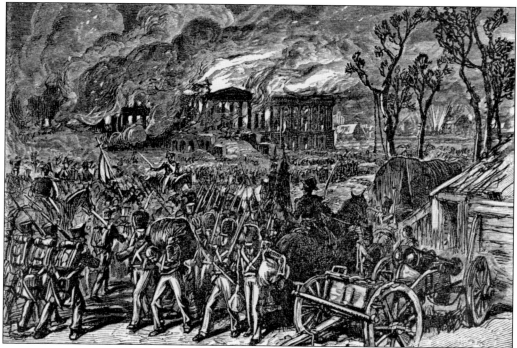

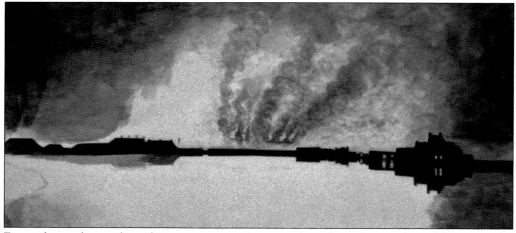

Five miles to the south, rushing to prevent a huge number of naval stores from falling into the hands of the British, a small force of Americans set fire to the Navy Yard, creating the most spectacular of all the conflagrations. The walls of Woodley would have shaken violently enough to break windows as a large store of ordnance was detonated. It stands to reason that Philip Barton Key would have sent his family and most of his slaves out to his tobacco plantation in Norbeck while he, as a former officer in the British Army, would have remained behind to ensure that no British soldiers would put the torch to Woodley. (LOC.)

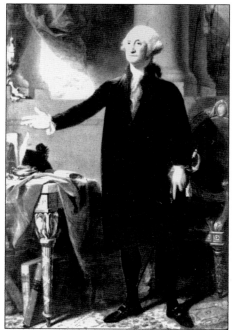

Earlier in the day, from the back porch of Woodley, Philip Barton Key might well have watched the presidential carriage heading for the banks of the Potomac. Inside was the redoubtable Dolly Madison, carrying a copy of the Declaration of Independence and Gilbert Stuart's full-length portrait of George Washington (above), which a servant had earlier cut from the frame with a penknife. The first lady and her precious cargo could then be seen climbing aboard a river bateau, which was zealously rowed upriver to safety. (LOC.)

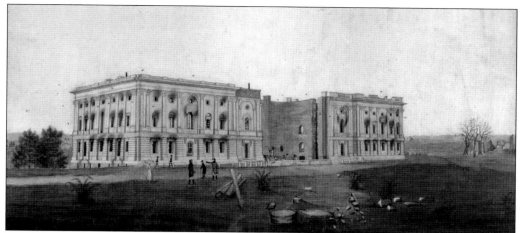

By the evening of August 25, the British evacuated the city of Washington, leaving behind four smoldering hulks of the once and future seat of government. However, they were commanded to avoid any damage to civilians or civilian property, and Gen. Robert Ross was such a respected figure that virtually no British soldier disobeyed him. According to the *National Intelligencer,* "No houses were half as much plundered by the enemy as by knavish wretches about the town who profited from the general distress." As to whether Woodley was affected by the looting, the record is silent. (LOC.)

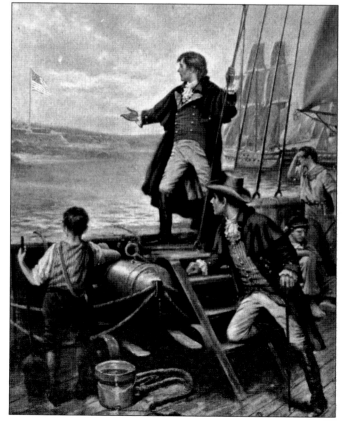

From Washington, the action shifted to Baltimore. Whereas the British had been able to enter Washington virtually unopposed, there would be fierce resistance in Baltimore, centered on Fort McHenry, a star-shaped fort that guarded the harbor. It was there on that night of September 16, 1814, while bombs were "bursting in air" that Francis Scott Key wrote the "Star-Spangled Banner." (LOC.)

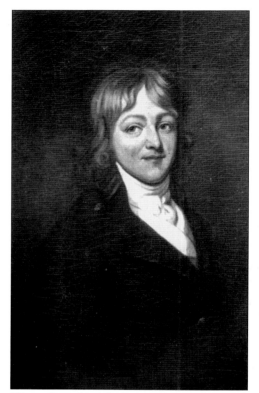

Throughout his life, Francis Scott, the nephew and protégé of Philip Barton, regarded Woodley as his second home. As a boy (left), he even etched his initials in the front window behind the staircase. Unfortunately, during the 1929 renovation of Woodley, a workman, who did not realize its importance, broke up that window and discarded the shards of glass. (Photograph by Lynn and Morris.)

Francis Scott Key's Eulogy to his Uncle Philip Barton Key

If nature's richest gifts could ever,
If genius, wit, and eloquence could charm,
If grief of sorrowing friends, or anguish wild
That wrong the widow's and the orphan's heart,
Could soothe stern death, and stay th' uplifted
stroke,
Long had this vision of his wrath been spared.
Mourning survivors! Let all care give place
To that great care that most demands your
thoughts:
The care that brings the troubled soul to Christ;
Fix there your hopes. There is, beyond the grave,
A life of bliss where death shall never more
Part you from joys that know no bound or end.

Philip Barton Key died at Woodley on January 28, 1815. His body was buried in a plot just south of the house. Francis Scott Key wrote this eulogy to honor the man he venerated as uncle, mentor, and lifetime hero.

WOODLY FOR SALE OR RENT,

THE seat of the late Mr. Key, two miles from George-town, in the District of Columbia, containing about 230 acres, costly and beautifully improved. This estate is in the best repair, most of the enclosures recently made, and the respective lots producing profitable crops of grass. Here the rural comforts are extensively diffus-ed ; the salubrity of situation, enlarged view of the city and Potomac with the surrounding country seats, are ob-jects peculiarly interesting. The mansion is a substan-tial brick edifice, with six rooms on the first floor, and three on the second, so conveniently disposed of, as to combine taste with utility—with every other necessary improvement for domestic purposes. The garden is spacious, and filled with a variety of the most choice fruit, and two apple orchards, of the best selection. Adjoining the dwelling is a green-house, tastefully and ornamentally constructed, the whole presenting to the spectator a most pleasing aspect for a residence, unequal-led in this vicinity. A sale is most desirable, and if con-sidered too large in quantity, it can be divided—there is one half in good wood. Should a purchaser not offer, a reasonable rent will be taken for it the ensuing year All persons wishing to possess such property, are invited to view the premises.

oct 14 –2awtf ANN KEY.

Subsequently, the house and its 250 surrounding acres became a bone of contention between Key's wife, Ann, and William Nevers, her Presbyterian minister son-in-law. Without the guiding hand of Philip Barton Key, the family's fortunes went into a steep decline. As a result, on October 14, 1818, Ann Plater Key placed an advertisement in the *National Intelligencer* offering Woodley for sale. This advertisement offers a remarkably detailed description of the house and land. Notice that by 1818, no tobacco was grown at Woodley. By then, the soil was exhausted and those fields, like so much of the upper South, were being planted with "grasses (hay)." (LOC.)

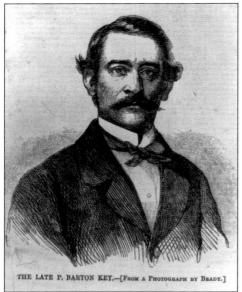

THE LATE P. BARTON KEY.—[FROM A PHOTOGRAPH BY BRADY.]

The Philip Barton Key who built Woodley is not to be confused with Francis Scott Key's son, also named Philip Barton Key (left), who was shot dead in front of the White House by a jealous husband, thereby becoming the object of one of the most sensational scandals of 19th-century Washington. In the illustration below, the body of Philip Barton Key is being carried to the Washington Club, where both he and his killer, Congressman Daniel Sickles, had been members. One of the people who consoled Sickles in the aftermath of the murder was Robert Walker, a future Woodley resident (see page 61). (LOC.)

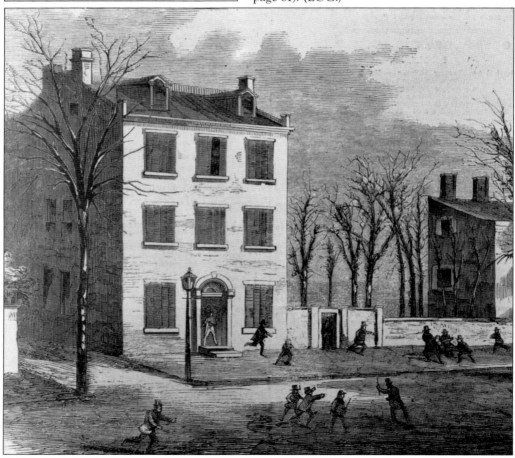

Three

THE
PRESIDENTIAL
YEARS

Pres. Martin Van Buren was a consummate politician who, in the words of one contemporary, "rowed to his objectives with muffled oars." Unfortunately, when he assumed the presidency in 1837, the country was plunged into a depression, so that he could not do what all his predecessors had done, such as move away from Washington during the summer. Instead, he rented Woodley because it was on the cooler heights above the city and because it was cheaper to run than the White House. During the summer mornings, Van Buren and his two sons, who acted as his secretaries, would stroll out under the Woodley portico, where saddled horses would be waiting. Once the three men were mounted, a groom would hand up to them saddlebags filled with papers and books. They would then ride three miles to the White House to conduct business, returning in the early afternoon. (LOC.)

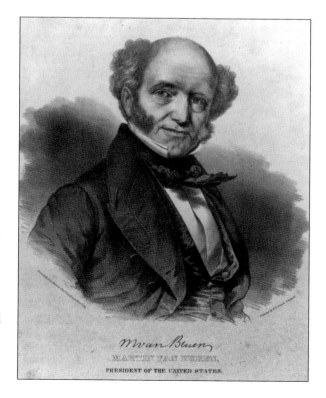

M van Buren

MARTIN VAN BUREN,

PRESIDENT OF THE UNITED STATES.

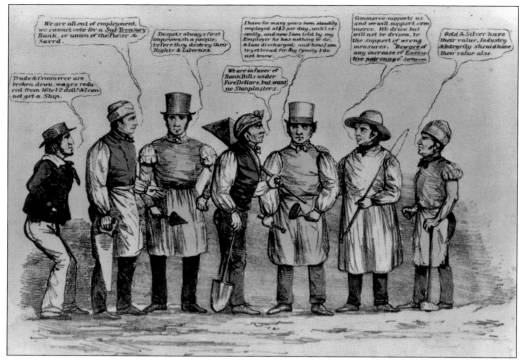

The Depression of 1837 was the most intractable problem with which Van Buren had to deal during his winters at the White House and his summers at Woodley. In the cartoon above, a variety of tradesmen are grumbling about economic conditions and Van Buren policies. The cartoon below shows the impact of the Depression on an individual family. (LOC.)

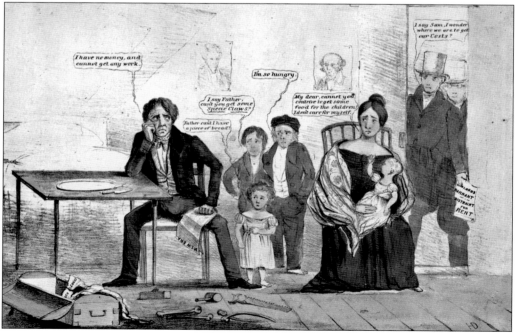

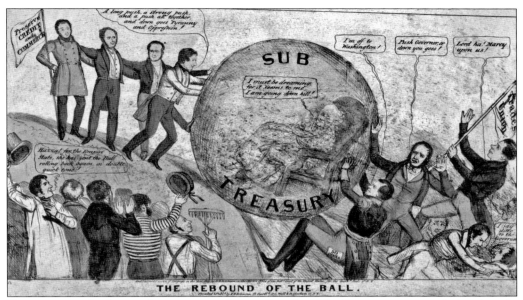

To counteract the forces of economic implosion, President Van Buren came up with the idea of a subtreasury system whereby government funds deposited in private state banks would be transferred to federal subtreasuries. It is conceivable that he hatched the scheme while pacing the halls of Woodley fretting about the state of the economy. This is one of the rare cartoons sympathetic to Van Buren. Here, he rolls the subtreasury juggernaut over protesting bankers while a sympathetic cross section of Americans looks on approvingly. (LOC.)

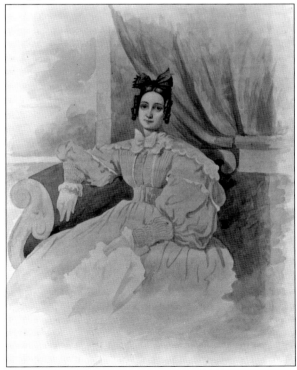

In November 1838, Martin Van Buren's son Abraham married Angelica Singleton (right), daughter of an aristocratic family from South Carolina. According to one contemporary, she was "universally admired" in Washington social circles. Because President Van Buren was a widower, Angelica filled the role of first lady while the president was in residence at Woodley in the summer of 1840. (LOC.)

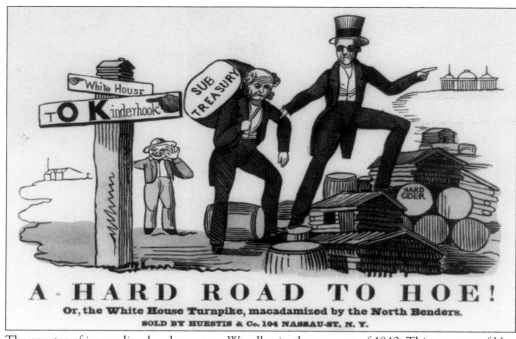

A·HARD ROAD TO HOE!

Or, the White House Turnpike, macadamized by the North Benders.

SOLD BY HUESTIS & Co. 104 NASSAU-ST. N. Y.

The specter of impending loss hung over Woodley in the summer of 1840. This cartoon of Van Buren weighed down by his subtreasury scheme summarizes the situation. He is still perceived as Andrew Jackson's flunky. His path is blocked by barrels of hard cider and log cabins, symbols of the campaign of his Whig rival, William Henry Harrison. On the right is the White House, which Van Buren will soon vacate. On the left is Van Buren's home at Kinderhook, New York, where he will live in retirement. Meanwhile, the youth thumbing his nose captures the mood of the day. (LOC.)

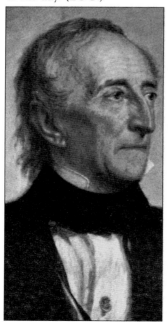

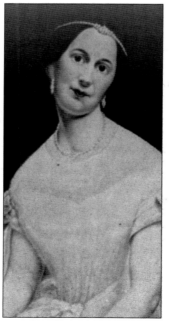

According to newspaper reports going back to the 19th century, John Tyler (left) was the second president to use Woodley as his summer White House. There is even one report that he spent his wedding night at Woodley with his lovely young bride, Julia Gardner (center). John Tyler was the Tyler of "Tippecanoe and Tyler, too," the Whig campaign slogan of 1840. "Tippecanoe" was the nickname of the man who unseated Martin Van Buren. Tyler was the unexpected president who went on to veto all the Whig legislation that Harrison would have signed and ended his term in office by annexing Texas. (LOC.)

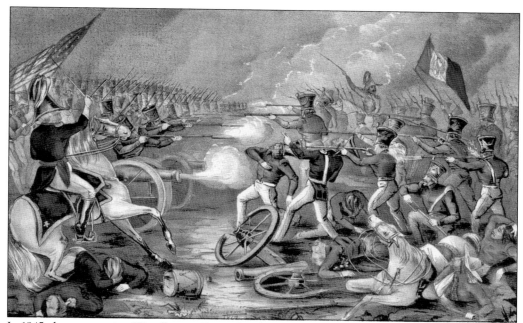

In 1845, the man renting Woodley was Baron Geralt, the German minister to Washington. On August 7, 1845, Baron Geralt relayed a report he had received from sources in Mexico that "3,000 Mexican soldiers had been ordered to the Rio Grande with another 10,000 to follow." That exaggeration would be one of the sparks that would ignite the Mexican-American War. (LOC.)

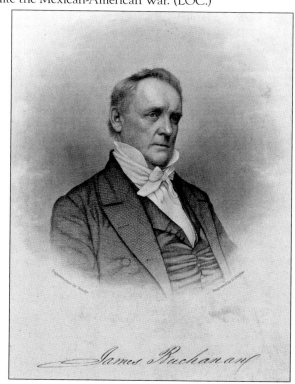

Although there are 19th-century newspaper articles stating that Pres. James Buchanan used Woodley as his summer White House, research indicates that it is far likelier that he lived at Woodley after his presidency. If so, he would have been recovering from a failed presidency (1857–1861), which included the Depression of 1857, his endorsement of both the Dred Scott decision and the Lecompton Constitution, legalizing slavery in Kansas against the wishes of the majority of its citizens, and the secession of the entire lower South. (LOC.)

James Buchanan

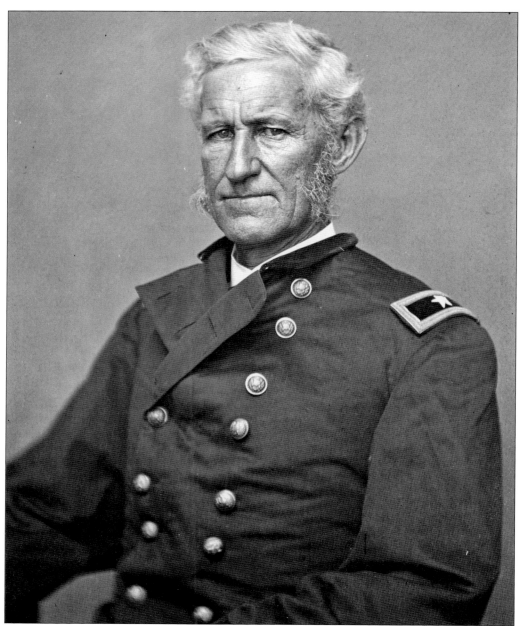

When Gen. Lorenzo Thomas bought Woodley in 1858, he was chief of staff for Gen. Winfield Scott, "Old Fuss and Feathers." Although Thomas suffered from both a drinking problem and an explosive temper, he played roles in a host of key episodes of American history. A graduate of West Point, he went on to fight in both the Second Seminole War and the Mexican-American War, and by the time the Civil War began, he was adjutant general of the army. Unfortunately for Thomas, Lincoln's secretary of war, Edwin Stanton, held Thomas in contempt. It was when Stanton assigned him to a post that was meant to humiliate him that Thomas achieved a level of selfless heroism that escaped him throughout the rest of his career before and after and won him the admiration of Pres. Abraham Lincoln. (LOC.)

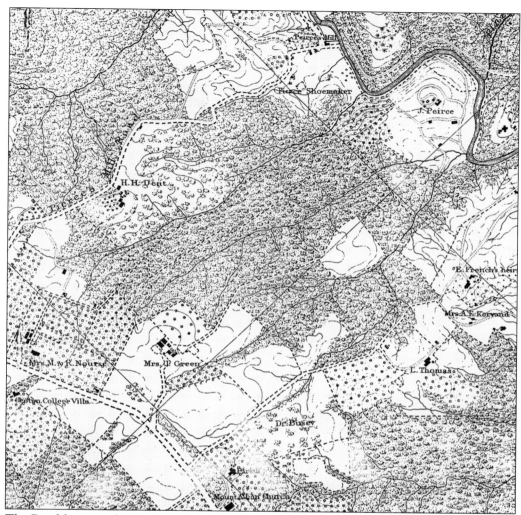

The Boschke map of 1861 shows Woodley when Lorenzo Thomas was in residence. Woodley is labeled "L. Thomas." The Mount Alban Church has been replaced by the National Cathedral, and the house labeled "Mrs. Nourse" is now Zartman House at Sidwell Friends School. (LOC.)

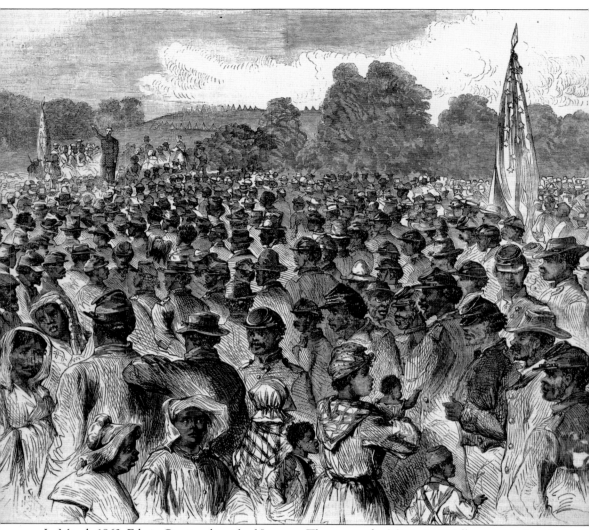

In March 1863, Edwin Stanton banished Lorenzo Thomas to the Mississippi Valley to recruit and train black troops. Historian Dudley Taylor Cornish describes the banishment as "one of the most fortunate pieces of spite work in the long history of the Civil War." By the end of 1863, Thomas had raised more than 20,000 black troops, most of them runaway slaves. He struggled to see that they were treated fairly. White officers who mistreated black soldiers were disciplined. And he made every effort to alleviate the poor living conditions of the families of his soldiers. His efforts paid off in both human and military terms. In the words of one contemporary, his efforts "completely revolutionized the sentiment of the army with regard to the employment of Negro troops." In this illustration, Thomas can be seen addressing his troops and their families. (LOC.)

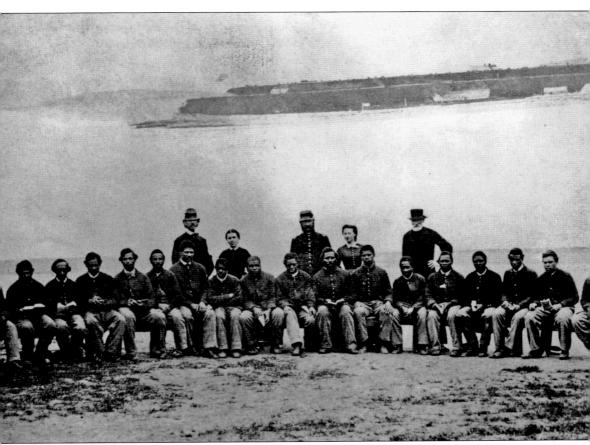

In this rare photograph from the Prints and Photographs Division of the Library of Congress, a company of black infantrymen are posed on the edge of a bluff overlooking the Mississippi River. Behind the soldiers stand their white officers and white teachers. Lorenzo Thomas recognized how important learning to read and write could be to the morale of a unit, so he brought down teachers from the North. In the decade after the Civil War, many of the freedmen who took part in the Reconstruction governments, could do so only because they had learned to read and write while serving in the army. (LOC.)

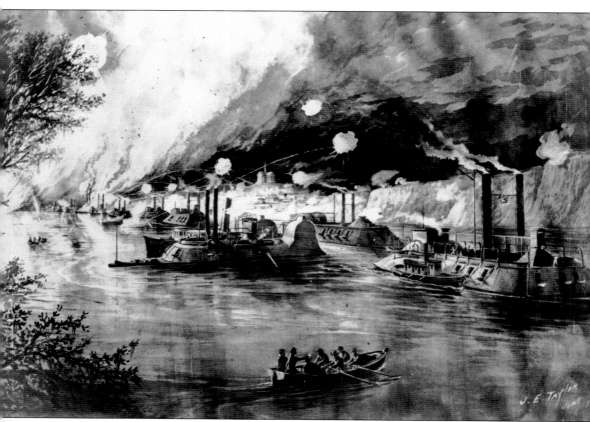

In early July 1863, while Union forces were winning the Battle of Gettysburg, Union general Ulysses S. Grant was busy capturing Vicksburg, the last great Confederate fortress on the Mississippi River. This illustration depicts the decisive night of April 16 when Union ironclads, gunboats, and rams steamed past the city's Confederate batteries. Once this river fleet reached the waters south of Vicksburg, Grant's army could be transported across the river and then go on to attack Confederate positions from the southeast, the area of greatest vulnerability. When the Confederates finally surrendered to Union forces on July 4, 1863, the entire length of the Mississippi River was controlled by Union forces, effectively cutting off the South from any access to Texas horses and cattle. Lincoln summarized the importance of the victory when he announced, "The Father of Waters now rolls unvexed to the sea." (LOC.)

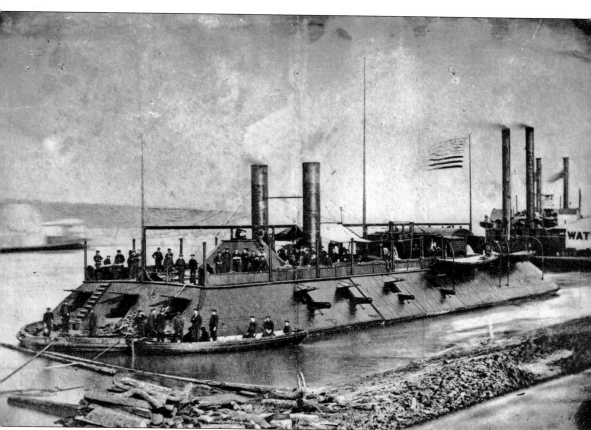

Once again, Lorenzo Thomas was at the heart of the action. He was on the deck of the *Magnolia*, an ironclad similar to the one in the photograph, on the night of April 16, close enough to watch the action. Seated in front of him were Ulysses S. Grant, the commanding general, Mrs. Grant, and their two small sons. The younger one sat whimpering in the lap of an aide with his eyes tightly shut. Grant held his wife's hand and quietly watched one of the decisive actions of the Civil War, his trademark cigar clenched between his teeth. (LOC.)

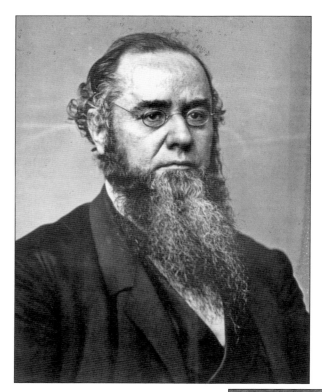

Throughout the latter stages of his career, Lorenzo Thomas was a figure of controversy. Edwin Stanton (above), Lincoln's secretary of war, used adjectives like "luke-warm," "incompetent," and "probably dishonest" to describe him. When Stanton assumed duties in the war department, he vowed to pick up Thomas "with a pair of tongs and throw him out a window." On the other hand, Lincoln (below), wrote to Stanton in July 1863, "I think the evidence is conclusive that General Thomas is one of the best (if not the very best) instruments for this service." Lincoln alone understood that during that brief assignment in the Mississippi Valley, Thomas ennobled himself. (LOC.)

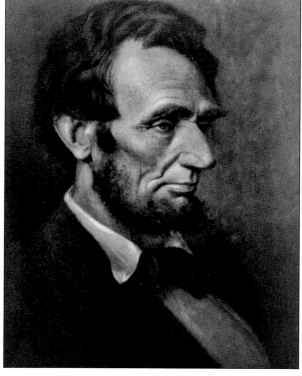

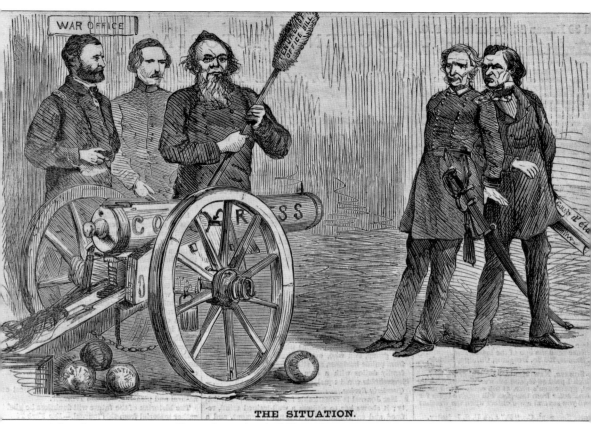

THE SITUATION.

After the assassination of Lincoln in April 1865, as the nation went into deep mourning, Andrew Johnson, a close friend of Lorenzo Thomas, assumed the presidency. Johnson turned out to be not only wildly out of step with the Republican Congress, but also tactless, irascible, and prone to drink. When it became clear that Johnson planned to fire Stanton, Congress set a trap by passing the Tenure of Office Act, which forbade the president to dismiss cabinet officers. In the cartoon above, Stanton holds the priming rod (marked "Tenure of Office Act") over the cannon of Congress aimed at Thomas and Johnson. Johnson is holding behind his back a document marked "coup d'état," which reflected one of Stanton's fears about Johnson's intentions. (LOC.)

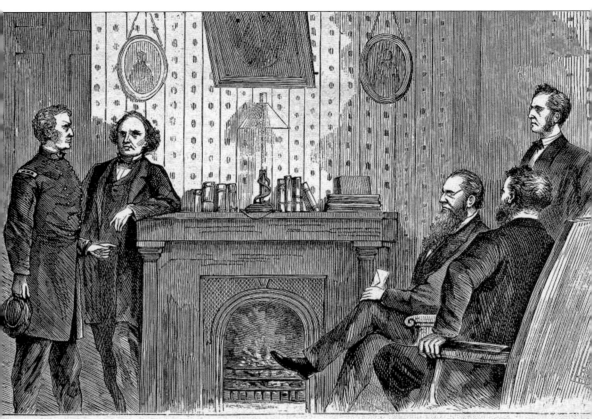

IMPEACHMENT—GENERAL THOMAS DEMANDING THE WAR OFFICE OF SECRETARY STANTON.

Johnson stepped willingly into the trap and fired Stanton, thereby violating the Tenure of Office Act. It was Lorenzo Thomas, whom Johnson had just appointed to be the new Secretary of War *ad interim*, who delivered the official letter of dismissal to his old enemy (above). The response was immediate. Even as the House was drawing up articles of impeachment, Stanton had Thomas arrested and led off to jail in handcuffs but relented the next day and had him released. There followed a Gilbert and Sullivan scenario wherein the two secretaries of war met and confronted each other with ever escalating epithets until Thomas produced a bottle of whiskey. Animosities suddenly disappeared, but it Stanton who ended up holding on to the War Department. (Courtesy of HarpWeek.)

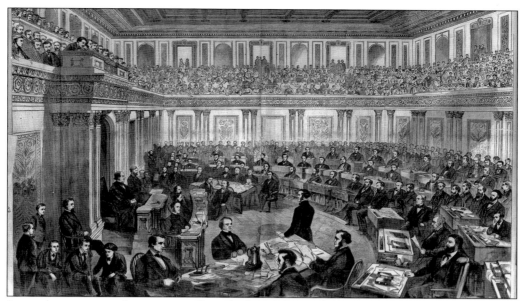

Impeachment proceedings against Pres. Andrew Johnson began on February 24, 1868, amidst "torrents of personal abuse." They proceeded like a poison carnival, feeding off the raw emotions of a war that had just ended and a revolution that was underway. Johnson was impeached in the House of Representatives by a vote of 126 to 47. Then the case went to the Senate for a three-month trial that riveted the attention of the nation and packed the galleries (above). Because one of the charges was that the appointment of Lorenzo Thomas was illegal, Thomas became a star witness (below). He attracted even more attention when he got drunk at a masquerade ball. Nevertheless, Andrew Johnson was acquitted on May 16, 1868. (LOC.)

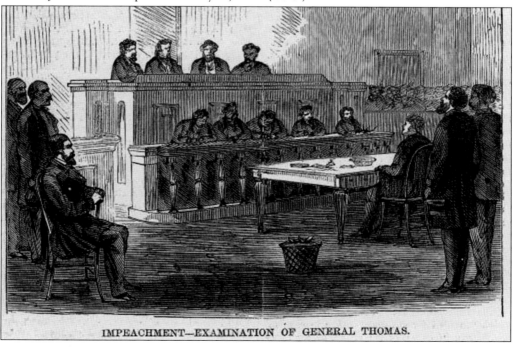

IMPEACHMENT—EXAMINATION OF GENERAL THOMAS.

To John. A. Smith Esqr.

Clerk of the Circuit Court of the District of Columbia for the County of Washington

Agreeable to the 9th section of an Act of Congress entitled "An Act for the release of certain persons held to service or labor in the District of Columbia" Approved 16 April 1862, the undersigned files the following schedule setting forth the names ages and description of those who were held by him to service or labor at the time of the approval of said act viz:

1. Lucy Berry aged about 43 years, 5 feet 3 inches high, copper color, stout build, good cook, washer and ironer.

2. George Berry, age 3 year delicate child of Lucy.

3. Lorenzo Berry, age 1 year healthy child of Lucy.

Washington April 30th 1862

L. Thomas
by Genl. U. S. Army

On April 16, 1862, Congress passed a law that Pres. Andrew Johnson and the white citizenry of Washington were dead set against. The bill in question was the District Emancipation Act, which announced that all the slaves in Washington were free from that day on. In accordance with the wishes of Abraham Lincoln, all slave owners were to be compensated. A commission of three men was established to determine the amount of compensation, but first, petitions had to be submitted in which each slave was briefly described in order to determine his or her value. The District Emancipation Act was passed five months before the announcement of the Emancipation Proclamation. In the document shown here, Lorenzo Thomas is petitioning for compensation after freeing Woodley's last three slaves—Lucy Berry and her two small sons. (NA.)

That your petitioner acquired *his* claim to the aforesaid service or labor of said *Coloured Person* in manner following:[2] *Lucy by Purcha from Eleanor Robertson of the State of Maryl on the 4th day of January 1853. the other two are the offspring of said Eleanor*

Lucy Berry

That your petitioner's claim to the service or labor of said *Coloured Persons* was, at the time of said discharge therefrom, of the value of *One thousand* dollars in money.[3] *the said Lucy Eight hundred Dollars the said George one hundred Dollar and the said Lorenzo, one hundred Dollar the said Lucy Berry a Good Servant as aforesaid. and to the best of his Knowledge and belief they have no defect Morally or otherwise except as before set forth*

Your petitioner hereby declares that *he* bears true and faithful allegiance to the Government of the United States, and that *he* has not borne arms against the United States in the present rebellion, nor in any way given aid or comfort thereto.

And your petitioner further states and alleges, that *he* has not brought said *Coloured Persons* into the District of Columbia since the passage of said act of Congress; and that, at the time of the passage thereof, said *Coloured Person* was held to service or labor therein under and by virtue of your petitioner's claim to such service or labor.

Your petitioner further states and alleges, that *his* said claim to the service or labor of said *Coloured Persons* does not originate in or by virtue of any transfer heretofore made by any person who has in any manner aided or sustained the present rebellion against the Government of the United States.

And your petitioner prays the said Commissioners to investigate and determine the validity of *his* said claim to the service or labor of said *Coloured Persons* herein above set forth; and if the same be found to be valid, that they appraise and apportion the value of said claim in money, and report the same to the Secretary of the Treasury of the United States, in conformity to the provisions of said act of Congress.

(Signed by) *L. Thomas*

Our narrative now shifts to Lucy Berry. The document above is part of a second affidavit filed by Lorenzo Thomas and affords a few more glimpses into the life of Lucy Berry. In addition to being a "good cook, ironer, washer, and an all-around good servant" (slave), it specifies that she had "no known moral defects." It also states that Lucy Berry was sold to Lorenzo Thomas by Eleanor Robertson. Finally, it gives the amount that Lorenzo Thomas was compensated for the three Berrys: $800 for Lucy and $100 for each child. (NA.)

This is a modern photograph of Eleanor Robertson's tobacco plantation near Port Tobacco in southern Maryland, where Lucy Berry lived, married in a slave ceremony that probably involved the old-African custom of jumping over a broom, and reared her first three children, whom she had to leave behind when she was brought to Woodley. Ironically, the name of the plantation was Equality. (Photograph by Will McAllister.)

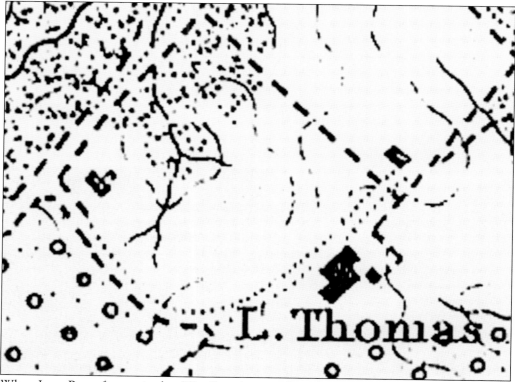

When Lucy Berry first arrived at Woodley, she must have been suffering deeply. She had been wrenched from her family and moved to a strange house in a strange city presided over by a general with a drinking problem and an explosive temper. In this detail of the Boschke map, behind the footprint of Woodley (marked "L. Thomas"), is the footprint of a small square building, which might well have been the slave cabin where Lucy Berry reared her two youngest sons. In addition to being the place where the family ate and slept, it would have been where Lucy would have done many of her domestic chores for the Thomases from washing and ironing to the food preparation that wouldn't have been done in the main house (like cleaning and scaling fish, putting up pork, and scalding possums for her own family.) (LOC.)

After the manumission of Lucy Berry and her two sons, it is unclear what happened to the family for the next three years. It was Civil War Washington. The African American population swelled from 4,000 to 40,000 as escaped slaves flocked to the city, perhaps Denis Berry and their older children were among them. Once the war ended, there was a rush of former slave couples seeking to formalize their old slave marriages. On December 7, 1865, Denis and Lucy Berry were legally married. By 1867, the reunited family was living in their own house in a part of eastern Georgetown then known as Herring Hill. According to *Boyd's Georgetown Business Directory*, the address of their house was "Monro nr. Gay" (see map), which is today near the corner of Twenty-seventh and N Streets, NW, an expensive section of Georgetown. (above LOC; below photograph by Alison Morris.)

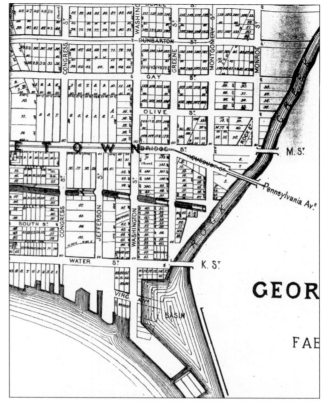

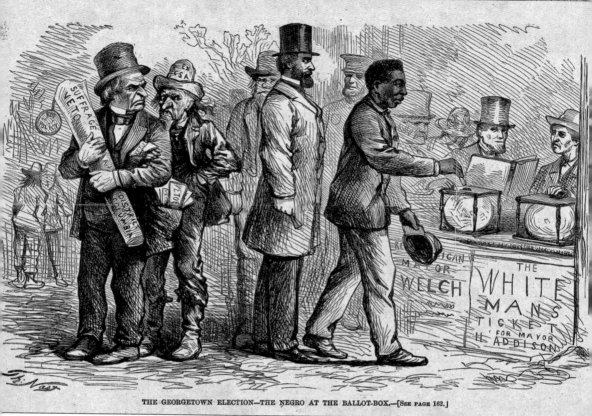

THE GEORGETOWN ELECTION—THE NEGRO AT THE BALLOT-BOX.—[SEE PAGE 162.]

By 1867, Reconstruction was underway. About that period, W. E. B. Dubois wrote, "The slave went free, stood for a brief moment in the sun, then moved back again toward slavery." Nowhere was this as true as it was for the "first freed" in Washington. In 1865, Washington streetcars were desegregated. In 1866, blacks in the District were given the right to vote four years before the passage of the Fifteenth Amendment despite local white resistance. Finally, in 1867, in the election for mayor of Georgetown, as depicted in this Thomas Nast cartoon, blacks actually voted despite a veto and a scowl from President Johnson (far left). Denis Berry might well have voted in that election. (Courtesy of HarpWeek.)

Record for Mrs Lucy Berry 969

Date, and No. of Application, Augt 5. 1867

Name of Master, Col Lorenzo Thomas

Name of Mistress, Elizabeth

Plantation,

Height and Complexion, Fair Age Dark.

Father or Mother? Married?

Name of Children, Dennis J. Matilda, Jane, Laemo Mary & George.

Regiment and Company,

Place of Birth, Charles Co Md.

Residence, Georgetown Monroe H. bet

Occupation, Dunbarton & Gay St.

REMARKS name of husband Dennis Berry $30

Signature, Lucy her X Berry

The year 1867 must have been a heady time for the Berry family. Lucy, Denis, and five of their children were living together in the house on Herring Hill. (Sadly, there is no mention of Lorenzo Berry listed in the manumission document as "the healthy child of Lucy." For whatever reason, he never again appears in any record.) Denis Berry was working as a laborer. In all probability, Lucy was taking in laundry. She had enough money, however, to deposit $30 in the Freedmen's Bank (above), an economic institution that helped finance black land purchases. Unfortunately, it failed in the Depression of 1873. Frederick Douglass wrote, "It has been the black man's cow but the white man's milk." (NA.)

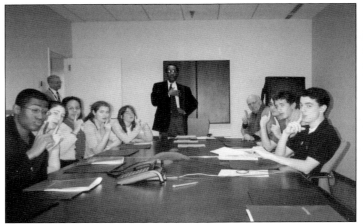
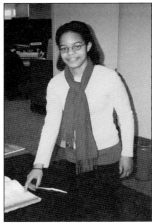

In February 2006, members of the Woodley Society of Maret School visited the National Archives in College Park, Maryland, to complete the study of Lucy Berry. It is known that the original note of deposit was filed away somewhere in the cavernous expanses of the archives. The climax of 18 months of research came when historian Ira Berlin produced the original note with its X marked by Lucy's very own hand. In the photograph on the left, students are preparing their fingers to touch that X. In the photograph on the right, sophomore Kendra Mitchell is actually touching it, and in so doing, coming as close as she or we would ever come to reaching Lucy Berry and her world. (Maret School Archives.)

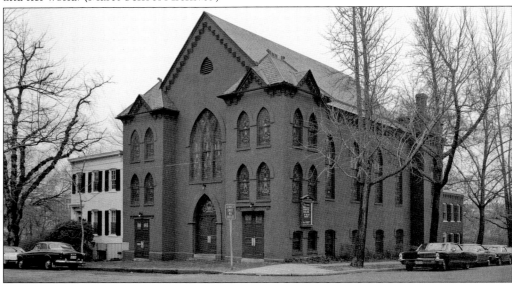

The Berrys belonged to the First Baptist Church of Georgetown. At the time the Berrys reached Herring Hill (East Georgetown), the church was housed in a simple frame structure that became inadequate for its growing congregation, so its founder, the Reverend Sandy Alexander, went north to raise money. The combination of money from northern aid societies and a loan negotiated by church members enabled the congregation to break ground for the current church on the corner of what is now Twenty-seventh and Dumbarton Streets. The men dug the foundation at night, while the women made them supper. But by the time the building was finished in 1883, Denis and Lucy Berry had died and their children had dispersed to different locations around the city. (LOC.)

Inquiries numbered 7, 16, and 17 are not to be asked in respect to infants. Inquiries numbered 11, 12, 15, 16, 17, 19, and 20 are to be answered (if at all) merely by an affirmative mark, as /.

SCHEDULE 1.—Inhabitants in _Georgetown_ in the County of _Washington_, State of _Columbia_, enumerated by me on the _22nd_ day of _July_, 1870.

607

Post Office: _Georgetown D.C._

W S O'Neal, Ass't Marshal.

		The name of every person whose place of abode on the first day of June, 1870, was in this family.	Age	Sex	Color	Profession, Occupation, or Trade of each person, male or female.	Value of Real Estate	Value of Personal Estate	Place of Birth, naming State or Territory of U.S.; or the Country, if of foreign birth.	Father of foreign birth	Mother of foreign birth	Born within the year	Married within the year	Attended school within the year	Cannot read	Cannot write	Whether deaf and dumb, blind, insane, or idiotic.	Male citizens 21	Male citizens 21 denied	
1																				1
1		Rogers Charles	4	M	B				Columbia											1
2	154 154	Murry John H.	47	M		Domestic Steward	200		Maryland							/		/		2
3		" Maria	37	F		Keeping house			" " "							/				3
4		" Israel A	18	M		Domestic Steward			" " "							/				4
5		" Mary	16	F		" " "			" " "							/				5
6		" Noah	13	M		" " "			" " "											6
7		" Margaret	11	F					" " "											7
8		Harrison Samuel	40	M		Common Labor			" " "							/		/		8
9		" Henry	13	M		at home			" " "							/				9
10		Enget Daniel	16	M		Domestic Steward			" " "							/				10
11	129 130	Goins Arthur	40	M		Blacksmith	400	100	Virginia							/				11
12		" Mariah	26	F		Keeping house			" " "							/				12
13		" Mary	30	F		at home			" " "							/				13
14	130 131	Turner Nathaniel	64	M		Common Labor	200		Maryland							/		/		14
15		" Ann	45	F		Keeping house			Virginia							/				15
16	131 132	Lawson Charles	30	M		Works on Farm yard			" " "							/				16
17		" Elizabeth	21	F		Keeping house			" " "							/				17
18		" Charles	2	M					Columbia											18
19		" George E	1	M					" " "											19
20		Lane Annie	25	F		at home			Virginia							/				20
21		" John	37	M		Common Labor			" " "							/				21
22		" John	11	M	B	at home			" " "							/				22
23		" William	8	M					" " "											23
24		" Alice A	4	F					Columbia											24
25		" Elizabeth	4/12	F					" " "		New									25
26	132 133	Alexander John	35	M	B	Blacksmith			Virginia							/		/		26
27		" Bell	24	F		Keeping house			" " "							/				27
28		" John	1	M	M				Columbia											28
29		Dickerson Betsey	64	F		at home			Virginia							/				29
30		Talbot Annie E	6	F	B				" " "							/				30
31	133 134	Berry Dennis	56	M		Common Labor	250		Maryland							/		/		31
32		" Lucy	50	F		Keeping house			" " "							/				32
33		" Thomas	26	M		Common Labor			" " "							/				33
34		" Jane	24	F		at home			" " "							/				34
35		" Lucinda	18	F		Domestic Servant			" " "							/				35
36		" May	16	F					" " "							/				36
37		" Boye	11	M		at home			Columbia							/				37
38	134 135	Pryor David	28	M	M	Smith Moulder	300		Virginia							/				38
39		" Lucy	34	F		Keeping house			" " "							/				39
40		" William	18	M		Works in Brick Yard			" " "							/				40

No. of dwellings, 7 No. of white females, ___ No. of males, foreign born, ___ No. of Insane, ___
" " families, 7 " " colored " 23 " " females, " ___
" " white males, 7 " " " females, 17 " " blind, ___

7 7 1550 103 22

The census of 1870 provides a wealth of information about the Berrys, including their ages and occupations. Denis Berry's net worth is listed as $250. The census also indicates that little George Berry, who was born at Woodley, could read and write and was attending school. It is now known that the school he was attending was the Chamberlain School, built in 1866 by the Freedman's Bureau. (LOC.)

Boyd's Business Directory of Georgetown has allowed us to plot the whereabouts of the Berry family on an annual basis. The directory lists them at the Monro Street address under Denis's name from 1867 until 1872. In 1873, they are listed under, "Berry, Lucy, wid Denis." We have no clues about the circumstances of the death of Denis Berry. The household then remained under Lucy's name until 1881, when she moved out. The two words next to her name in the 1881 edition are "insane asylum." (LOC.)

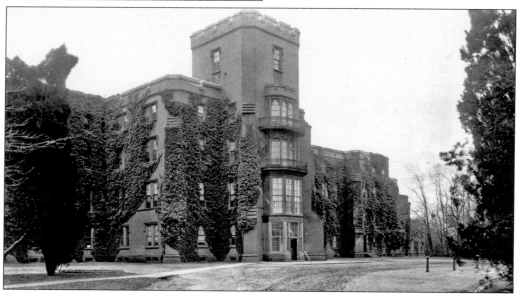

The insane asylum mentioned in *Boyd's Directory* was the Government Hospital for the Insane, now known as St. Elizabeths Hospital, located south of the Anacostia River in southeast Washington (above is the Center Building of St. Elizabeths). Founded in 1852 by Dorothea Dix, it was the first federally funded psychiatric hospital in the nation. Lucy Berry worked there as a laundress for two years. We know from the salary listings that she was paid $10 a month, and that all supervisors were white and most of them were Irish. Almost all of the laundresses and cooks were black, and most of the older ones were former slaves. Lucy Berry, the last of the Woodley slaves, died there in 1883. (NA.)

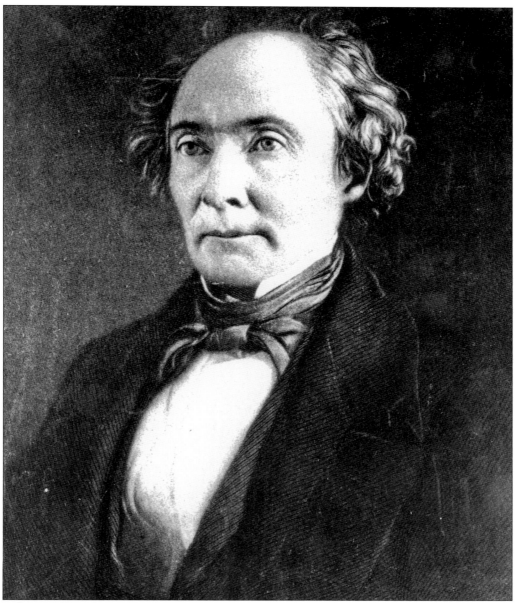

Robert Walker, who purchased Woodley in 1866, was once described as "a mere whiffet of a man." Despite his small size, he cast a long shadow. He was brought up in Northumberland, Pennsylvania and attended the University of Pennsylvania, where he finished first in his class. He then moved to Natchez, Mississippi, where he made and lost several fortunes speculating in land, cotton, and slaves. Along the way, he was catapulted into politics and ended up being elected to the Senate in 1834 as a champion of Andrew Jackson and his frontier politics. Never far from controversy, he challenged both Henry Clay and Thomas Hart Benton to duels during his 10-year stint in the Senate. (LOC.)

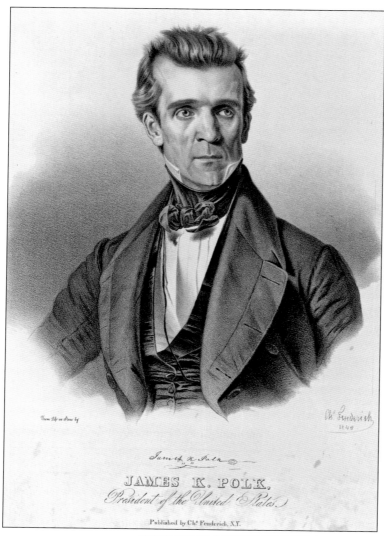

JAMES K. POLK,
President of the United States

Published by Ch.ᵃ Fenderich, N.Y.

In 1844, Robert Walker engineered the election of James K. Polk (above), the first dark-horse candidate to be elected president. Polk appointed Walker to secretary of the treasury, a post where he served with extraordinary distinction.

Walker revived the independent treasury scheme of former Woodley resident Martin Van Buren and fashioned what became famously known as the Walker Tariff, which reduced rates but increased trade to such an extent that it raised revenue. He also issued a 25¢ note (below) with his own picture on it that is now a favorite of collectors. (LOC.)

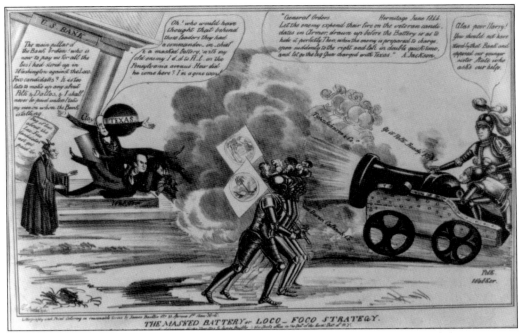

Perhaps what most distinguished the Polk administration was expansionism and the Mexican-American War in which this nation acquired California, the New Mexico Territory, and southern Texas. In this cartoon, James K. Polk stands behind the cannon with tiny expansionist Robert Walker beside him and fires a cannonball marked "Texas" at Henry Clay, his 1844 presidential opponent and critic of Texas annexation. (LOC.)

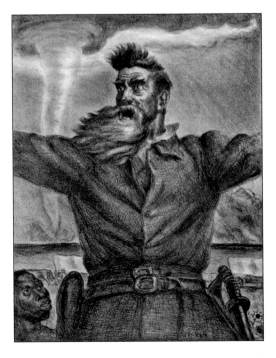

In 1857, Pres. James Buchanan, probable Woodley resident, appointed Robert Walker, future Woodley resident, governor of the Kansas Territory. It turned out to be an impossible assignment. Kansas was rife with violence. It was there that pro-slavery elements ran an extra-legal government, and John Brown (above) retaliated and massacred six slave owners with broadswords at Pottawatomie Creek. Walker went to Kansas with the understanding that the fate of slavery in the territory would be settled by the will of the majority. Slowly, he came to realize that he had become a "marked man, about whom whirled, for a brief moment, the destiny of the nation." Unfortunately, Buchanan accepted a pro-slavery constitution that was clearly against the will of the majority, and Walker resigned in justifiable indignation. (LOC.)

By the time of the Civil War, Robert Walker was an outspoken Unionist and critic of the institution of slavery. He had freed all his own slaves long ago. The man who had once championed the principles of Jefferson Davis now belonged to the opposite camp. Therefore, Abraham Lincoln wrote him a letter of credence and sent him to London both to borrow money for the Union and to damage the credit of the Confederacy. In the late summer of 1863, Robert Walker, a man with a flair for the dramatic, flew over London (above) in a balloon while dumping pro-Union pamphlets denouncing Jefferson Davis and the cause of the South. (LOC.)

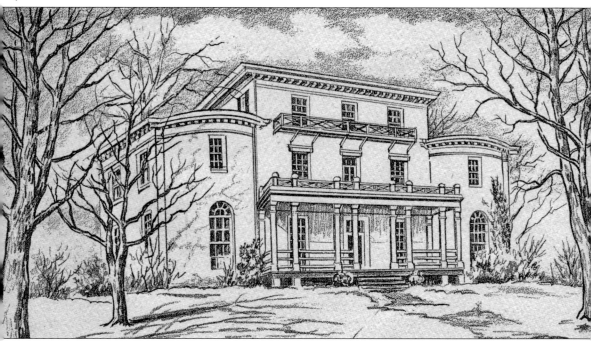

In 1866, after the end of the Civil War, Robert Walker was back in Washington, where his health was slowly worsening, and his finances were in crisis. Charles Francis Adams wrote, "Sickness and debt seemed permanently attached to the old man." Nevertheless, Walker resumed his law practice and bought Woodley. He also served as the lobbyist for the Czar of Russia who had decided to sell Alaska to the United States despite a highly suspicious Congress. The Czar paid Walker a lump sum of $26,000 in gold, most of which went to bribing members of the House and Senate. But with what was left, Walker renovated and enlarged Woodley. He added a third floor to the central block and a second floor to the two side projections. The upshot of all this was that by the end of 1867, Alaska was part of the United States, and Woodley had assumed the silhouette it has kept to this day.

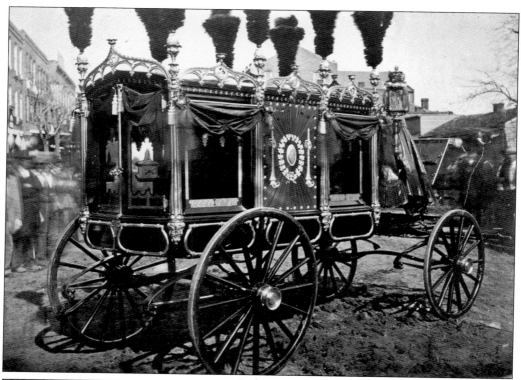

Robert Walker's health and financial situation continued to spiral downward. Circumstances became so dire that he made one last unavoidable decision—an agreement to sell his beloved Woodley. But before the transaction was finalized, his health grew suddenly worse, and his family assembled by his Woodley bedside. On the morning of November 11, 1869, he awoke from a coma, looked around at his family and a retinue of old servants and asked, "What have I done to deserve such love?" Then he quietly died. There followed a funeral service in the Woodley parlor while outside it began to snow. As the small coffin of Robert Walker was carried out under the portico toward the waiting horse-drawn hearse, stray snowflakes were landing and melting on the polished lid. (LOC.)

After the death of Robert Walker, Woodley went into probate. In 1875, Woodley was purchased by a Samuel Middleton. Then in 1892, Francis Newlands (left), a big-time developer who was in the process of buying up everything in the neighborhood, bought Woodley and the surrounding 40 acres to use as both a rental and a speculation. (LOC.)

In 1893, Pres. Grover Cleveland rented Woodley from Francis Newlands. Cleveland, or "Uncle Jumbo" as he was known by then, had begun his political career as the Democratic mayor of Buffalo, where he established a life-long reputation for integrity, hard work, and minimalism in government. He then went on to be elected governor of New York, where he broke down the power of Tammany Hall, New York City's hard-core municipal machine. In 1884, he defeated Republican candidate James G. Blaine for the presidency. (LOC.)

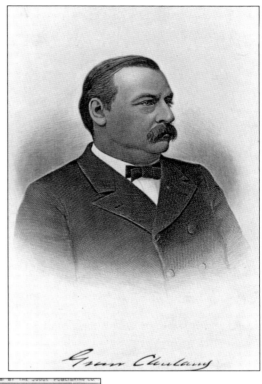

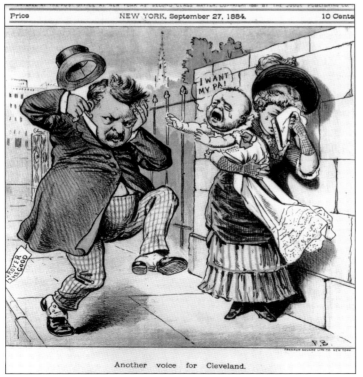

Another voice for Cleveland.

The election of 1884 had been one of the dirtiest on record. Early in the campaign, it came to light that Cleveland had fathered an illegitimate child 10 years previously. Cleveland took full responsibility from the beginning. "Tell the truth," was his message. But it gave the Republicans a doggerel with which to flog him for the rest of the campaign: "Ma, ma, where's my pa? Gone to the White House, ha, ha, ha!" The Democrats' equally edifying response was, "Blaine, Blaine, James G. Blaine, the continental liar from the state of Maine." (LOC.)

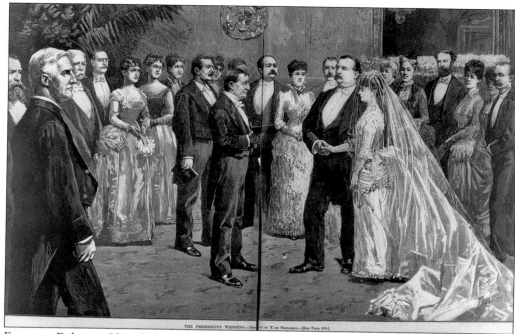

THE PRESIDENT'S WEDDING.—Drawn by T. de Thulstrup.—[See Page 378.]

Frances Folsom Cleveland, who presided over the White House and Woodley as Cleveland's first lady, was so popular that an element of the Washington Press Corps was transformed into the Washington paparazzi. She was lovely, engaging, and 21 when she married 49-year-old Grover Cleveland in the Blue Room of the White House. "Frankie," as she was known to friends, was adored by all, from ambassadors and cabinet officers to clerks and servants. Even her menagerie of various-sized dogs never seemed to want to leave her side. (LOC.)

Cleveland lost his bid for a second term in 1888, but when he recaptured the presidency in 1892, "Baby" Ruth Cleveland, born a year earlier, joined her mother as a darling of the Washington Press Corps. She became such a celebrity that a candy bar was named after her. And years later a rotund Yankee home-run hitter was nicknamed for the candy bar. In those days, when the public had nearly total freedom to roam the White House grounds, poor little Baby Ruth was subjected to hugs by strangers and, on one occasion, had a lock of hair cut from her head. It was on account of incidents such as this that Grover and Frances Cleveland chose to make Woodley their primary residence during his second term in 1893–1897. (LOC.)

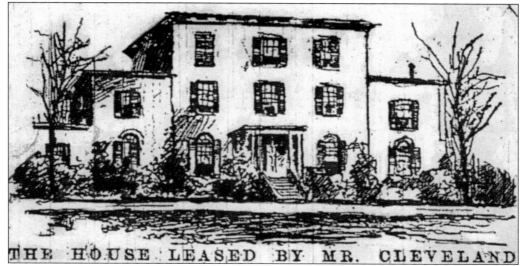

THE HOUSE LEASED BY MR. CLEVELAND

This article goes on to describe Woodley as a "large rambling structure built after the style of an old English country seat and occupying an ideal location. In fact, its situation is perhaps the finest in that whole Rock Creek region—on high ground—embowered in an ancient forest of trees, on the summit of a hill of mild declivity." (LOC.)

MR. CLEVELAND'S COUNTRY HOME
A FINE OLD MANSION ON THE WOODLEY ROAD

NOW BEING MADE READY FOR HIM

THE PRESIDENT AND MRS. CLEVELAND ARE GOING TO HAVE A HOME IN THE COUNTRY AS they did four years ago. By the end of the present month it is expected that the Middleton House on the Woodley Lane road will be ready for their occupancy. Mr. Cleveland has leased the place for a term of years from Mr. Francis Newlands.

Evening Star: *Washington, D.C., April 4, 1893*

Another article describes what it was like to walk through the front door of Woodley and approach the president's office. "Upon reaching the house and stepping upon the porch, we enter the portals. We are in a wide vestibule, to the left of which is the stairway, and opening from the vestibule on the left is a door that leads to the president's office. Even here the cares of office sometimes invade, but he is prepared to meet every emergency." (Maret School Archives.)

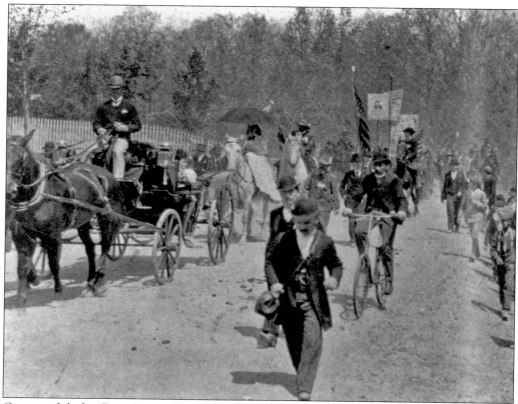

One month before Pres. Grover Cleveland moved into Woodley, the stock market collapsed, which began a series of crises that shook this nation to its very core and threw a pall over the Clevelands' years at Woodley. In 1895, James Coxey led an "army" of 500 protesters to Washington to demonstrate for a massive public works program and jobs for the unemployed. They marched in file down Pennsylvania Avenue (above). The protest ended lamely when Coxey was arrested for walking on the grass. Then the cavalry was set loose to scatter the rest of the grim, ragged men. (LOC.)

The Pullman Strike was another seismic shock that Cleveland had to confront while sitting at his desk at Woodley. When George Pullman, sole owner of the Pullman Palace Car Company, cut the wages of his workers, a strike ensued that temporarily paralyzed large parts of the Midwest. In Chicago, rioters took to the street, setting buildings ablaze and burning or otherwise destroying hundreds of trains (left). Cleveland sent federal troops to deal with the rioters and then went on to see to it that Eugene Debs, president of the American Railway Union, ended up in jail. Order was restored, but in the process, Cleveland won the undying enmity of the American labor movement. (Courtesy of HarpWeek.)

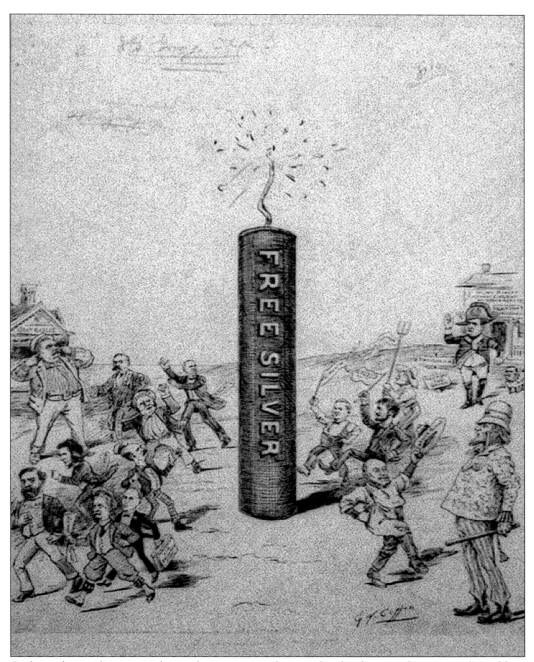

Perhaps the single most explosive domestic issue during Cleveland's second term was that of free silver. On the one hand, there were the farmers and the silver-mine owners who wanted unlimited coinage of silver as an inflationary stimulus to the economy. On the other hand, there were the merchants, the bankers, and the Wall Street crowd who wanted all currency to be backed by gold. Cleveland belonged to this crowd. That issue would not only cost him the Democratic nomination in 1896, but it would also create deep-seated enmity with his Woodley landlord, Francis Newlands, a silver-mine owner. (LOC.)

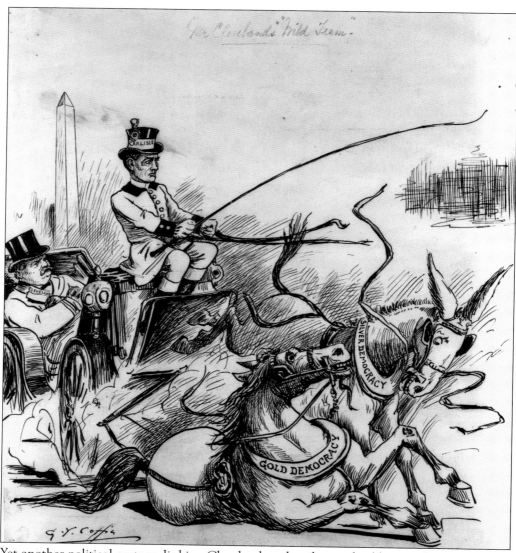

Yet another political cartoon linking Cleveland to the silver-and-gold issue, this one actually has a direct connection to Woodley. On the evening of April 22, 1895, when Cleveland was returning from the White House to Woodley in a two-horse carriage, one of the horses stumbled and tripped up the other. The two horses ended up on their backs, kicking out in all directions and breaking lamps, harnesses, and a dashboard. The press got hold of the accident, blew it wildly out of proportion, and it evolved into this cartoon. The one inaccuracy in the cartoon is that Cleveland was actually driving the carriage at the time of the accident. (LOC.)

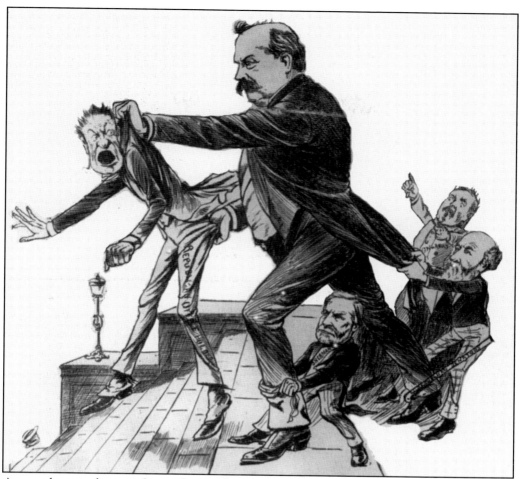

Among the most dramatic face-to-face confrontations between a president and Congress took place at Woodley in April 1896. A delegation from Congress came storming into Woodley demanding that, on account of Spanish efforts to put down a rebellion in Cuba, Cleveland support a declaration of war against Spain. Cleveland flatly refused. One member then reminded Cleveland that the U.S. Constitution gives Congress the right to declare war, to which Cleveland responded that the U.S. Constitution gives the president the right to mobilize the army, and Cleveland said firmly, "I will not mobilize the army." The congressmen were then sent packing, metaphorically tumbling out the front door, and the Spanish-American War was thereby postponed for another two years. (LOC.)

The usually cautious Cleveland took this nation to the brink of war involving a boundary dispute between Venezuela and British Guiana. When gold was discovered near the mouth of the Orinoco River, the British attempted to establish their boundary in order to include the gold fields. The Venezuelans resisted, so Cleveland stepped in and offered to arbitrate. The British refused the offer, at which point Cleveland threatened war. In this cartoon, the British lion is attacking the Venezuelan maiden, while Cleveland stands, gun in hand, waiting to go to the rescue. In fact, the British did agree to arbitration, and the dispute was settled peaceably. (LOC.)

This was the tightrope that Cleveland had to walk during his last year at Woodley. With the help of a number of Western "Silver Senators," and the terrible turmoil of his second term, he turned the reins of the Democratic party over to William Jennings Bryan, whose "Cross of Gold" speech, extolling free silver, would become one the most famous in American history. Cleveland went into "honorable retirement" in Princeton, New Jersey, where his daughter, Baby Ruth, died in 1904, and a broken-hearted former Pres. Grover Cleveland died two years later. (LOC.)

Four

WOODLEY
IN THE
20TH CENTURY

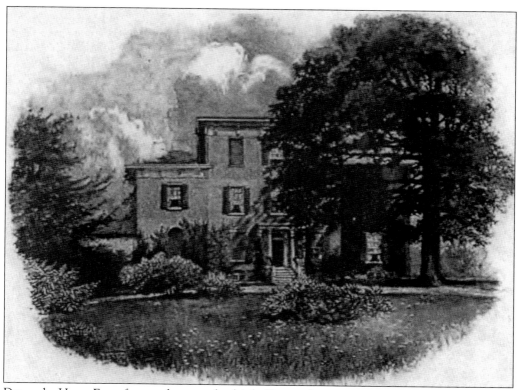

Drawn by Harry Fenn from a photograph, this half-tone plate was engraved by C. W. Chadwick.

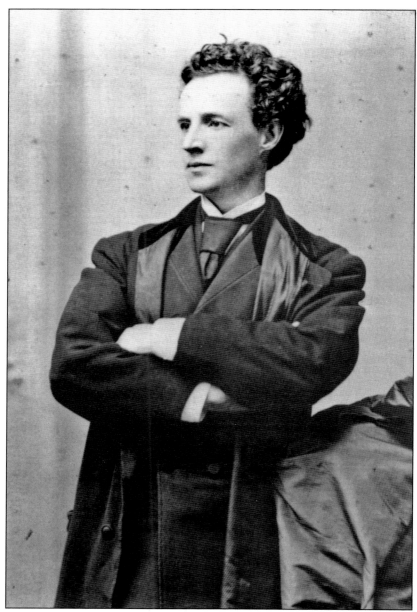

Francis Newlands, congressman, senator, real estate tycoon, and big-time developer, moved into Woodley in 1900. His life had been one of financial and political ascent. He was born in Natchez, Mississippi, in 1848. Three years later, his spendthrift father died leaving the family virtually destitute. In 1863, at the height of the Civil War, the family moved to Washington, D.C. Somehow they managed to drum up enough tuition money to send young Francis to Yale as an undergraduate. He then went on to put himself through law school at what is now George Washington University studying at night and working as a clerk in the post office by day. In 1869, he joined the westward migration and moved to San Francisco, where the notorious William Sharon hired him as a young attorney. (Francis Newlands Papers, Manuscripts and Archives, Yale University Archives.)

In many ways, William Sharon was the embodiment of the "Gilded Age." His snarling ruthlessness was legendary. He had made a fortune in San Francisco real estate and then in 1863, plowed that fortune into the Comstock Mine, the richest deposit of silver in North America. In 1874, it was Newlands's turn to strike it rich when he married Sharon's daughter Clara. (LOC.)

Following the scent of precious metals to their source, Francis Newlands moved his young family to Nevada in 1888 and became one of the largest landowners in the state. In 1892, he was elected to the House of Representatives. Government service were what brought him to Washington and eventually to Woodley in 1900. Among his most notable achievements were the Newlands Reclamation Act of 1902, which would lead to the irrigation of vast areas of the West, and the 17th Amendment, which began the direct election of U.S. senators. But Newlands commanded the most sustained attention from the press and the public in 1912 as chairman of the Senate subcommittee investigating the sinking of the *Titanic*. (LOC.)

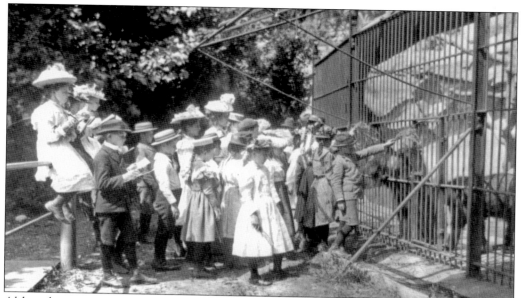

Although an instinctively modest man, Newlands was the ultimate string puller. He developed picturesque suburbs in three states. And in the District of Columbia, he was the guiding force behind the creation of Rock Creek Park and the Zoological Park, now the National Zoo, which was (and is) only two long blocks from Woodley. In all his endeavors, an appreciation of landscape and the traditions of the area were key considerations. (LOC.)

Newlands's role in the creation of Rock Creek Park was an example of doing good while doing well while doing bad. The park is an outstandingly beautiful piece of urban landscape design. The citizenry of Washington have been the beneficiaries ever since. It also took 2,200 acres of prime real-estate off the market, which made Newlands's nearby land purchases at Chevy Chase that much more valuable. Unfortunately, it was also conceived as a barrier to keep "undesirable elements" away from areas of white affluence. As such, it was unfortunately consistent with Newlands's retrogressive principles. Although he was in many ways "a lifelong, thick and thin, two o'clock in the morning progressive" as one admirer described him, he sponsored a constitutional amendment that would have restricted the vote to white males. (LOC.)

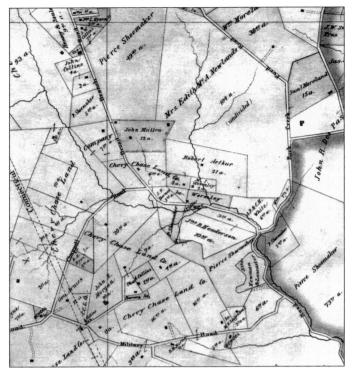

In terms of the new phenomenon of suburbanization, Newlands turned out to be a visionary. By the late 19th century, a number of forces were pushing cities outward such as increased urban congestion, introduction of the electric trolley, and the emerging ideal of the restorative nature of the countryside. So when Newlands moved to Washington as a freshman Congressman in 1893, he began looking for land where he could create his own community. He settled on Chevy Chase, Maryland, then undeveloped farmland only six miles from downtown Washington. (Courtesy of Paul L. Williams.)

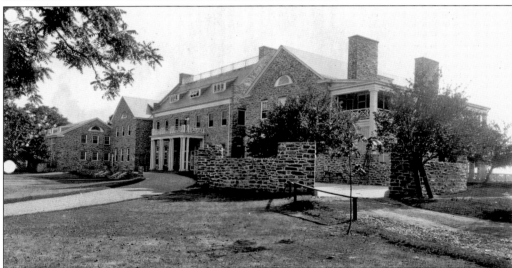

In order to purchase the land without disclosing that he was the purchaser, Newlands sent out a number of straw men to buy up farms from unsuspecting farmers. By 1890, he had accumulated 1,713 acres from 31 different owners. When his intentions became public, he formed the Chevy Chase Land Company, which continued to accumulate more contiguous acreage. To Newlands's everlasting credit, his vision became reality. What he created turned out to be a community as well as a suburb. In addition to building houses, Newlands built a first-class hotel, a fox hunting club (above) (now the Chevy Chase Club), a library, a post office, a school, an artificial lake, and an amusement park with a dance pavilion. (LOC.)

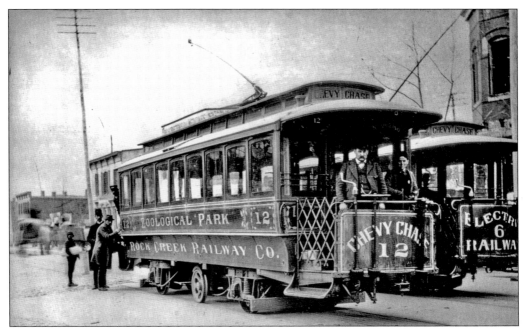

Francis Newlands bought the Rock Creek Railway Company to manage the streetcar commute between Chevy Chase and downtown Washington. Inventory consisted of 25 electric streetcars boasting a top speed of 17 miles an hour. "Zoological Park" was painted on the sides of each streetcar, because one of the stops on the line was the Washington Zoo. (Robert Truax Collection, Chevy Chase Historical Society.)

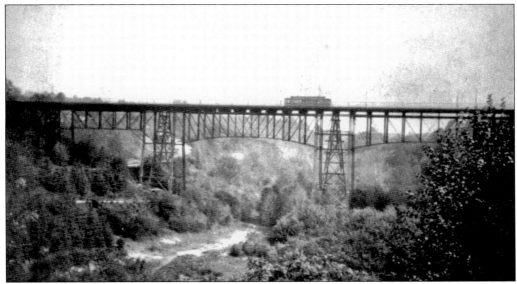

To move streetcars and other traffic back and forth from downtown Washington to Chevy Chase, Frances Newlands oversaw the construction of Connecticut Avenue. Two bridges had to be built, and the excavation ended up being far more extensive than Newlands had foreseen. One Newlands associate wrote, "The hills had to be cut down by pick and shovel and the valleys filled by horse-drawn carts." (Courtesy of Paul Williams.)

Originally, Newlands had planned Connecticut Avenue to run northwest until it intersected Wisconsin Avenue, but an unforeseen problem arose when a farmer, whose land was on the proposed route, learned of Newlands's secret scheme and raised the price of his land to a level that Newlands considered exorbitant. With characteristic bottom-line cold-bloodedness, Newlands decided not to deal with him. Instead, he changed the angle of Connecticut Avenue at the Maryland border so that instead of continuing northwest, the avenue shifted due north. At the point of the shift in angle, Newlands put in the Chevy Chase Circle, which now has a sandstone fountain (above) in the center. Behind the dense foliage on the far side of the circle still stands the enormous house that was owned and occupied by Newlands until his second wife, Edith, decided that it was too far from the city, and the couple therefore decided to move to Woodley. (Photograph by Charles Fishl.)

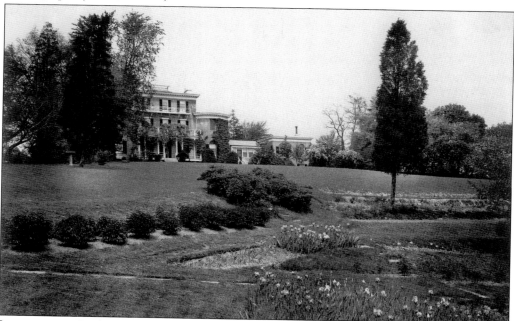

In preparation for their move into Woodley, the Newlands added a block of rooms to the east side, which can be seen on the right side of this photograph. Although this photograph was taken in the 1920s, it accurately shows the downtown side of Woodley as it would have appeared when the Newlands first moved in. (Courtesy of the Ellis family.)

Nevertheless, there was a lingering problem: Newlands remained upset that he had allowed his arch-nemesis, Pres. Grover Cleveland, to live in his house. (Recall that Cleveland wanted American currency backed only by gold not silver, and Newlands was Comstock-loaded.) So Newlands proposed what amounted to a political fumigation. He wrote the following in a letter to William Jennings Bryan (right), the great apostle of free silver and the man who took the Democratic nomination away from Cleveland in 1896: "I am now living at Woodley, the place, which I leased to Cleveland during his second term. I am not proud of his association with it and if you would only occupy it for a time, I will regard it as dedicated to high principle and morality. It is a little way out of town, but I think Mrs. Bryan and yourself could spend a week or two very comfortably there." In the cartoon below, Woodley denizen Cleveland and would-be denizen Bryan, grind their hurdy-gurdies in support of their two antithetical positions on free silver. (LOC.)

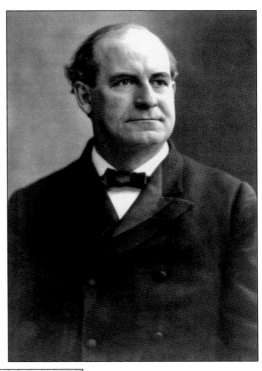

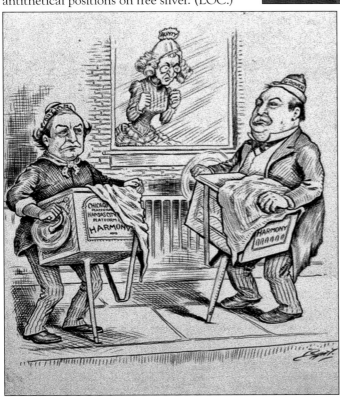

In 1916, Sen. Francis Newlands moved out of Woodley and into a residence on Massachusetts Avenue, for reasons that are unclear. A year later, on December 24, he suffered a heart attack while working at his Senate chamber and died later that night at his new home with his wife at his bedside. He was buried at Oak Hill Cemetery, where he joined former Woodley residents Philip Barton Key and Ann Plater Key (who decades before had been moved from the burying ground at Woodley and reinterred on a shady hillside at Oak Hill), Robert John Walker and Mary Bache Walker (who was the great-granddaughter of Benjamin Franklin as well as the wife of Robert Walker), and Gen. Lorenzo Thomas. This photograph shows the entrance to Oak Hill Cemetery. Photography is forbidden within the cemetery itself. (Photograph by Alison Morris.)

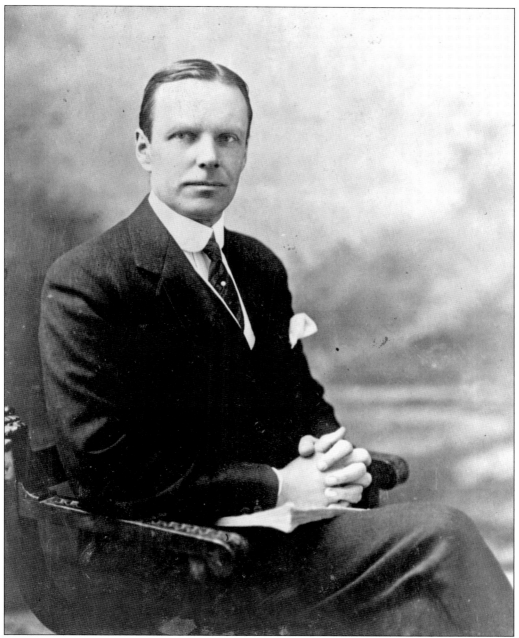

After moving to Massachusetts Avenue, Newlands rented Woodley to Billy Phillips, who was recently appointed by Pres. Woodrow Wilson to be assistant secretary of state. Phillips who was variously described as "young, suave, elegant, and cautious," "distinguished and courteous" a man whose "dress, gentlemanly manners and direct talk" reminded a fellow foreign-service officer of what he had found "admirable in the upper reaches of Boston society." Former president Theodore Roosevelt thought so highly of him that he tried to marry him off to one of his nieces. Instead, Phillips married the even wealthier Caroline Astor Drayton. Their wealth opened doors to them that were closed to other career diplomats and explains how they could afford Woodley.

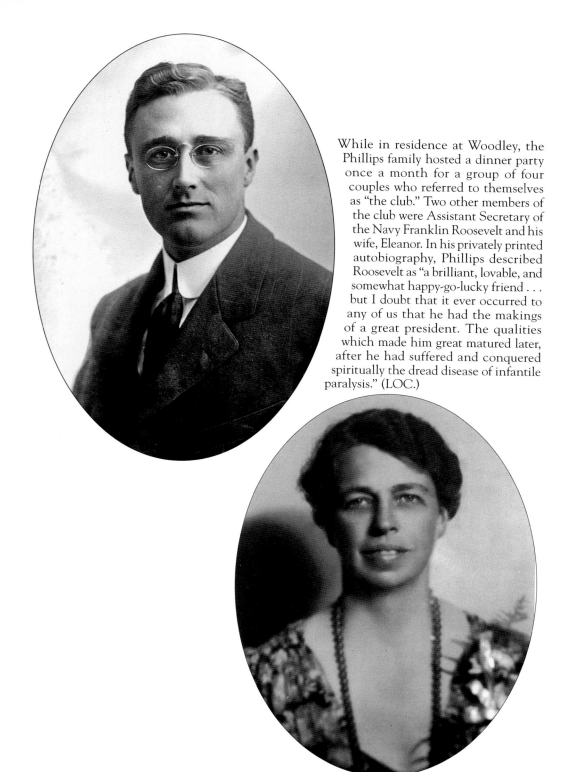

While in residence at Woodley, the Phillips family hosted a dinner party once a month for a group of four couples who referred to themselves as "the club." Two other members of the club were Assistant Secretary of the Navy Franklin Roosevelt and his wife, Eleanor. In his privately printed autobiography, Phillips described Roosevelt as "a brilliant, lovable, and somewhat happy-go-lucky friend . . . but I doubt that it ever occurred to any of us that he had the makings of a great president. The qualities which made him great matured later, after he had suffered and conquered spiritually the dread disease of infantile paralysis." (LOC.)

This is the only photograph in the Prints and Photographs section of the Library of Congress that shows Billy Phillips and his friend Franklin Roosevelt in the same image. What is depicted here is a part of the Wilson administration on Flag Day, 1914. The bald man in the white jacket on the left is Secretary of State William Jennings Bryan. President Wilson stands to his left holding his keynote speech. Billy Phillips is the dark-haired young man looking downward beneath the cannon, and a tall, youthful Franklin Roosevelt stands in the front row to Billy Phillips's left, seemingly ready to take on the world. (LOC.)

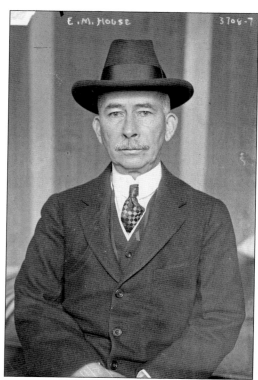

In 1916–1917, Billy Phillips also served as host for a number of top-secret meetings. Col. Edward House (above left), Pres. Woodrow Wilson's alter ego, would be driven from the White House to a location a block away from Woodley. Then he would leave car and driver and proceed on foot. British ambassador Cecil Spring-Rice (above right) and French ambassador Jean Jusserand would be waiting for him in the Woodley library (later Stimson's study). Those meetings may have well determined the timing of the United States entry into World War I. (LOC.)

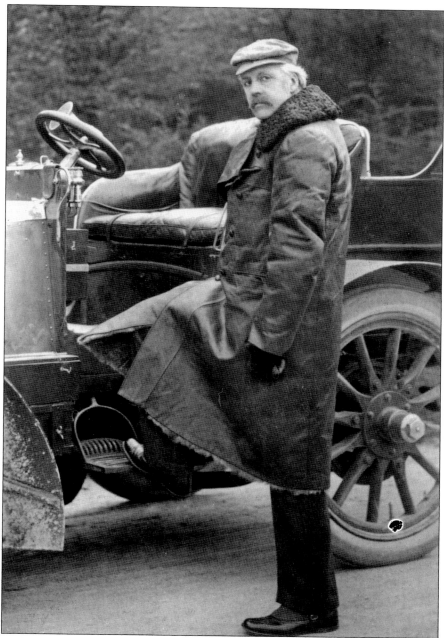

In his autobiography, Phillips describes an evening when he and Caroline were just settling down for a quiet dinner alone when they heard the whir of motorcycles, and up the Woodley driveway came a limousine with a motorcycle escort. The motorcade stopped in front of the portico and into Woodley strode Sir Arthur Balfour, British foreign secretary and former prime minister, in full evening dress expecting a dinner party. Phillips cordially greeted his distinguished guest and then pulled aside the butler, who informed him that the larder was bare. So an embarrassed Billy Phillips had to send Sir Arthur and his escort back into the evening after working out a date for a future luncheon. (Maret School Archives.)

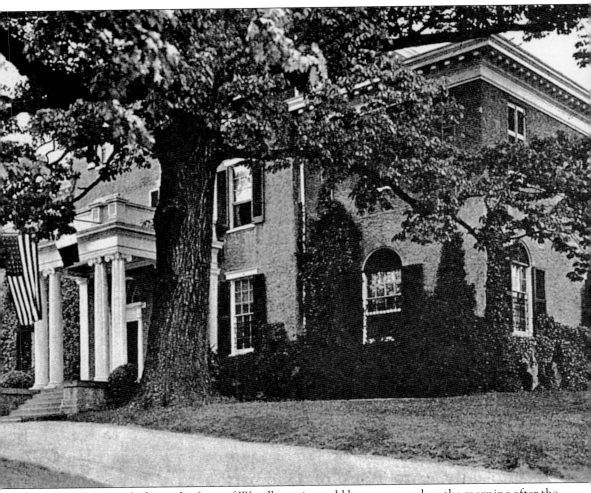

This photograph shows the front of Woodley as it would have appeared on the morning after the unexpected visit of Sir Arthur Balfour. (Maret School Archives.)

On October 3, 1918, just as World War I was coming to a close, R. A. Long, a lumber tycoon from Kansas City, Missouri, bought Woodley from the Newlands Company and gave the estate to his daughter, Sallie Long Ellis (right). By 1918, the estate included a house, a gardener's cottage, and stables all situated on 18 acres of prime Washington real estate. The Ellis family would add a tennis court on the west side of the house. (Courtesy of the Ellis family.)

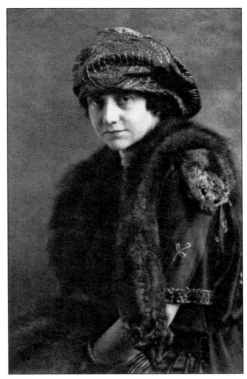

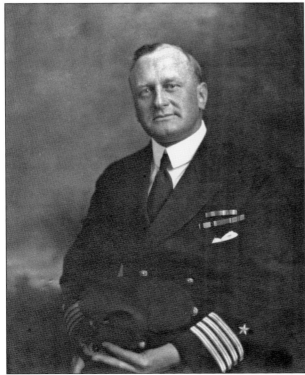

Sallie Long Ellis, new owner of Woodley, was married to Capt. Hayne Ellis, USN. Born in Macon, Georgia, Hayne Ellis had gone on to the U.S. Naval Academy at Annapolis, Maryland. In the summer of 1898, while the Spanish-American War was raging on two sides of the world, he sailed up the East Coast of the United States on the gunboat USS *Annapolis*, and as a result, would draw a life-long pension for his Spanish War service. (Courtesy of the Ellis family.)

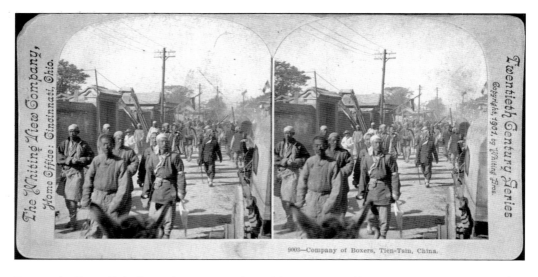

Company of Boxers, Tien-Tsin, China.

During the Boxer Rebellion of 1900 in northern China, Hayne Ellis was serving on the battleship USS *Brooklyn*, the flagship of the Asiatic fleet. The Boxers (above) were, for the most part, armed peasants who believed that killing all foreigners and destroying all foreign influences would usher in a new golden age. While an international delegation was trapped in Beijing and an army composed of soldiers of eight nations was slowly fighting its way into the city to rescue the delegation, the *Brooklyn* (below), with Hayne Ellis aboard, was landing an additional 350 marines on the coast and then steaming up the Pehlo River to relieve an international force at Tianjin. (LOC.)

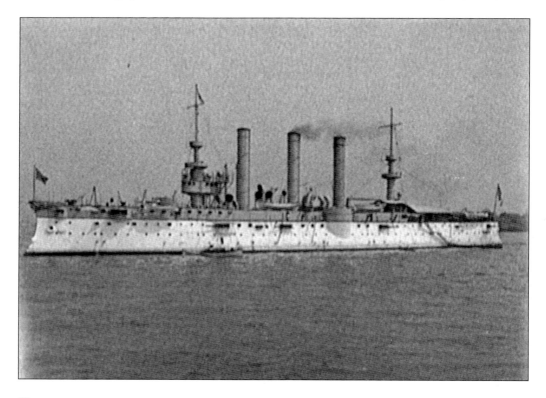

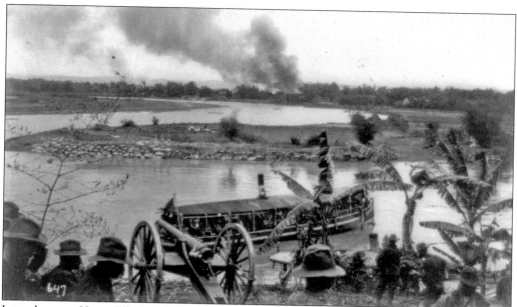

Later that year, Hayne Ellis found himself enmeshed in the Philippine Insurrection. After the Spanish-American War, Pres. William McKinley decided that it would be best for all concerned if American forces remained on the islands. That decision turned the insurrection against the Americans. In the dirty little war that followed, both sides committed unspeakable atrocities. Hayne Ellis wrote the following: "The Filipinos would stand hidden, then rush our men as they passed, using big bolas, etc. They also dug pits in the trail and had pointed sticks with poison on them. We drank no water ashore. They poisoned that, too." Ellis's detachment burned caches of rice and destroyed the fish weirs they assumed belonged to the enemy. The photograph above shows an American squad in the foreground while the Philippine village of Pasig is being burned in the background. The photograph below shows a squad of American rifleman under attack. (LOC.)

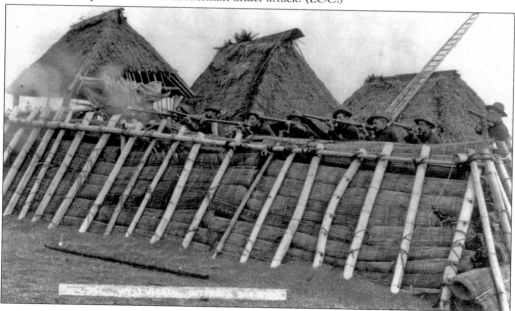

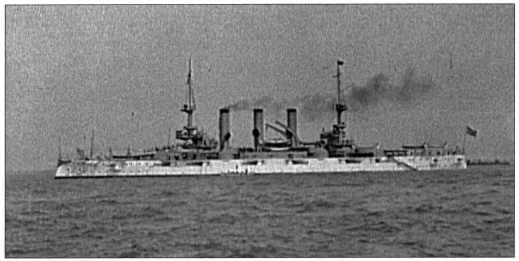

In the fall of 1907, Hayne Ellis was assigned to the USS *Connecticut*. He wrote the following: "[The *Connecticut*] was our latest battleship, and to me she was the best sea ship I was ever on. She carried four 12-foot guns and twelve 7-foot guns and was very heavily armored; speed—about 18 knots. At the time before the so-called "Dreadnaughts," she was about the most powerful ship afloat." (LOC.)

The USS *Connecticut*, with Hayne Ellis aboard, was one of 16 battleships that comprised the "Great White Fleet." As conceived by Pres. Theodore Roosevelt, its mission was to circumnavigate the globe to give fair warning to all nations, particularly Japan, of American naval might. In this photograph, the fleet is assembling off Hampton Roads, Virginia. In this photograph, President Roosevelt, on board the presidential yacht *Mayflower*, is reviewing the Great White Fleet. In accomplishing its mission, the fleet steamed 43,000 miles and made 20 port calls on six continents. (LOC.)

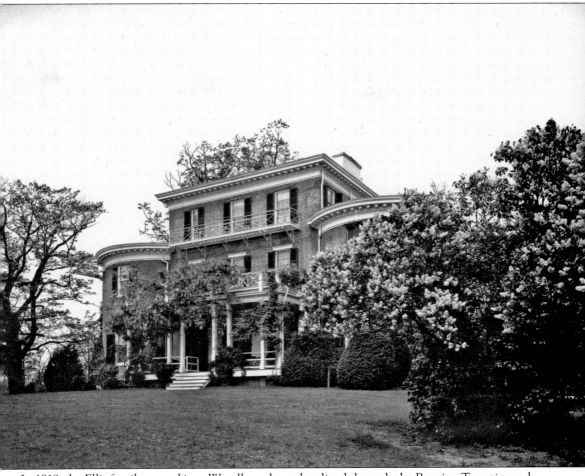

In 1919, the Ellis family moved into Woodley, where they lived through the Roaring Twenties and Prohibition. Hayne Ellis had by then attained his rank of captain and was serving as president of the Naval Examining Board. Sallie Long Ellis was busy playing hostess at elaborate dinner parties and dedicating herself to a variety of local causes. When Lucia Ellis Uihlein, the Ellis's youngest daughter, was asked if the family observed Prohibition, her forceful and immediate reply was, "My mother was a teetotaler. She wouldn't even let those Frenchmen drink!" When Mrs. Uihlein was asked how many servants it took to run Woodley, she couldn't recall exactly, but she said she could remember "a chauffeur, a cook, a part-time cook who 'lived out,' two chamber maids, two nannies, a housekeeper, a gardener, and a night watchman." (Courtesy of the Ellis family.)

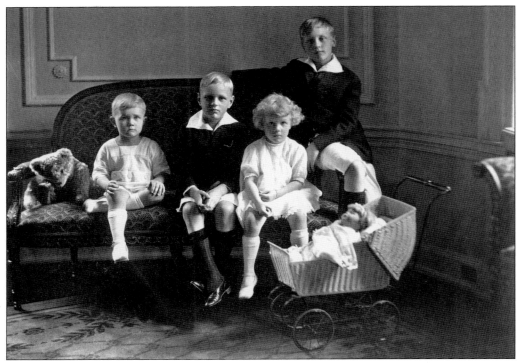

The four Ellis children seated in this photograph are Robert, Hayne, Lucia, and Long (seated next to the Teddy Bear). (Not pictured here is Martha Ellis, the eldest child) Seven decades later, Long and Lucia (Uihlein—see page 94) returned to Woodley to give unforgettable recollections of what it was like to grow up there. (Courtesy of the Ellis family.)

Mrs. Ellis referred to this hallway (added by Francis Newlands in 1900) as the "closed porch." It served as both the children's dining room and a screening room where movies were shown until one evening when Mrs. Ellis came in during a movie in which a body was being stuffed into a trunk. Immediately, Mrs. Ellis stopped the movie. No more movies were shown in the closed porch. (Maret School Archives.)

There are no photographs of any of the upstairs rooms when the Ellises were in residence. This room, now the office of the head of Maret School, was once Mrs. Ellis's bedroom. Mrs. Ellis so frequently saw what she thought was a ghost in this room that she slept with a loaded pistol under her pillow. To this day, the bedroom door will open or close for no apparent reason, and in an adjoining room, there are still times when one can smell a whiff of smoke when the building is otherwise empty. (Photograph by Charles Fishl.)

In 1919, the Ellises gave a dinner party in honor of Gen. John Pershing, the commander of the American Expeditionary Force that helped win World War I for U.S. allies. He had recently assumed a stature of near mythic proportion, as can be seen in this poster. Just before the dinner, two of the Ellis children spilled a bowl of hollandaise sauce onto the pantry floor, and in terror of what might happen to them if they were discovered, they scooped the hollandaise off the floor with rags and squeezed it back into the bowl. Later that night, Mrs. Ellis was hard-pressed to explain the peculiar pungency of the hollandaise. (LOC.)

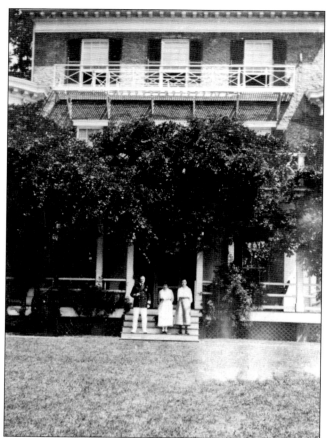

From left to right in this 1924 photograph, Capt. Hayne Ellis, Sallie Long Ellis, and an unidentified guest stand on the steps to the Woodley porch. In those days, the porch was shaded by wisteria vines. (Courtesy of Lamar Leland.)

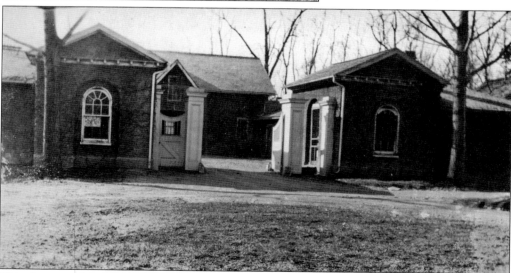

This photograph helps to explain why Woodley was owned by so many serious horsemen. Pictured here are the Woodley stables, which were not only extensive but were built around an elegant courtyard. (Courtesy of Lamar Leland.)

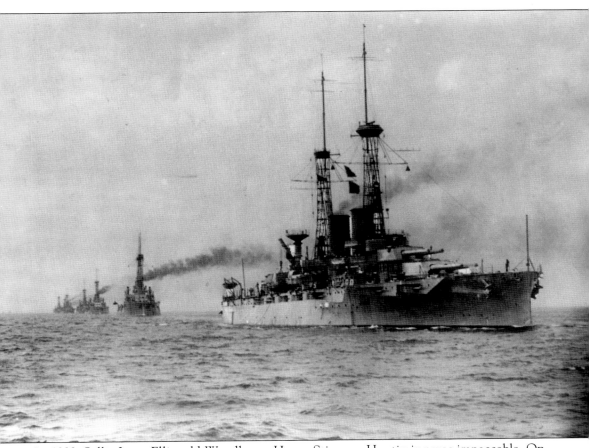

In 1929, Sallie Long Ellis sold Woodley to Henry Stimson. Her timing was impeccable. On October 29 of that year, the stock market crashed, the Depression followed, and a way of life disappeared. Hayne Ellis went on to work his way further and further up the Naval ladder until, in 1940, he became admiral of the North Atlantic Squadron. In this photograph, the USS *Texas*, Admiral Ellis's flagship, leads the fleet. During his long absences, Sallie Long Ellis presided over a very full household and pursued a variety of philanthropic interests but was otherwise limited due to a weak heart, which finally made the long steep climb up the Woodley staircases untenable. So the Ellises reluctantly made the decision to sell their beloved Woodley. (LOC.)

"THE EPIC AMERICAN WAR MOVIE THAT HOLLYWOOD HAS ALWAYS WANTED TO MAKE BUT NEVER HAD THE GUTS TO DO BEFORE."
—Vincent Canby, New York Times

"YOU MAY NEVER HAVE ANOTHER EXPERIENCE LIKE IT! EVIDENTLY SOMEONE BELIEVED THAT THE PUBLIC HAD COME OF AGE ENOUGH TO TAKE A MATURE FILM ABOUT A REAL WAR WITH A HERO-VILLAIN IN ALL HIS GLORIOUS AND VAINGLORIOUS HUMANITY."
—Liz Smith, Cosmopolitan Magazine

PATTON

GEORGE C. SCOTT · KARL MALDEN in "PATTON"

The year before the Ellises sold Woodley, the house was rented to Maj. George Patton, the only Woodley resident about whom an academy award-winning movie has been made. Patton rented Woodley because there were enough stalls in its stables for his entire string of polo ponies. During that year, he could often be seen galloping over the front lawn smacking a polo ball and generally scaring the wits out of the gardener. Ironically, Patton was in Washington as an aide to the chief of cavalry in order to argue the case for tanks, which would ultimately make cavalry horses obsolete. In World War I, Patton had been wounded in the thigh and decorated as a tank commander in France. (Courtesy of the Ellis family.)

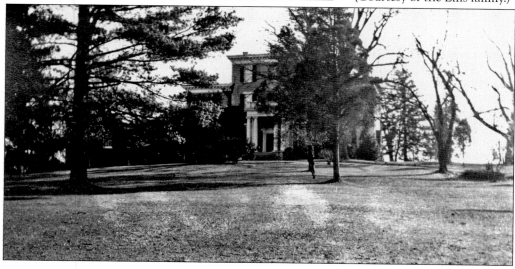

George Patton first came to national attention
as a volunteer in a punitive raid into Mexico in
1916. Earlier that year, Pancho Villa (right), the
charismatic rebel general of the Mexican Revolution,
had crossed the Rio Grande and proceeded to
Columbus, New Mexico, where he had murdered
16 civilians. In response, President Wilson sent a
force of 6,000 troops deep into Mexican territory
to capture or kill Villa. Gen. John Pershing, future
Woodley dinner guest, was placed in command
of the expedition, and Lt. George Patton, future
Woodley resident, was made his aide. (In the
photograph below, taken in the mountains of
Mexico, Patton is the fourth from the left). In his
first taste of combat, Patton so distinguished himself
that the press made him an overnight sensation
and Pershing promoted him to captain. Meanwhile,
Hayne Ellis, future Woodley resident, was cruising
off the coast on board the USS *Connecticut*. (LOC.)

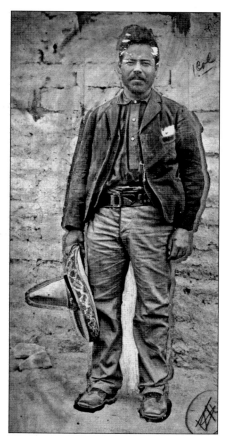

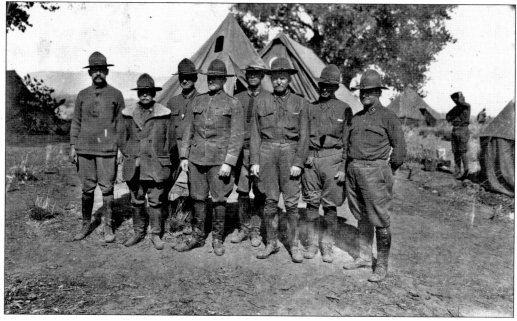

 Friday .

 (Woodley - 1929)

Darling Beat:

 You must be a wonderful horse nurse. I am awfully
sorry that you have had so much trouble in this affair
perhaps he will make you a fine hunter by way of payment.

 Little B is realy doing awfully well and is working
hard I think that every thing will be moved out with out
doubt by Monday night.
 Maj. our neighbor has just been in and
swears.that he never made the complaints anyhow he is going sea
and the Secretary owns the place so what the hell. carbon
 As we wont be ready to move until Monday I think
that little B had just as well come up with me on Wednesday
night on the Federal

 Enclosed is a copy of an article I wrote for the
Hearst papers by request. It is just Tank propaganda and
was hard to write as I did not want to do any thing that
could be used against the horse.

 As I wrote it in two sittings and failed to have your
help either in criticism or punctuation it is not much good
but if it is accepted I get $250.00

 We had a very bad polo game yesterday and to day it
is raining so I guess we wont have one tomorrow. Have
heard of several new houses with fixings.

 I love you
 George

This is a copy of a letter written in early 1929, three days before the Pattons moved out of Woodley.
It gives insights into just how large a role horses played in George Patton's day-to-day existence,
how wistful he was about the ultimate replacement of the horse by the tank, and how tender he
could be towards his wife, whom he called "Beat." (Manuscript Room, Library of Congress.)

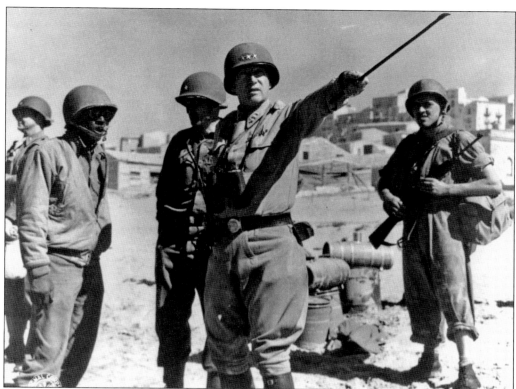

During World War II, Patton earned immortality as one of the greatest field generals in American history. After leading armies through North Africa, Sicily, and Italy, he took command of the Third Army, which swept through France defeating whatever elements of the German military machine were thrown in their way. It was then that he earned the sobriquet "Old Blood and Guts." In the photograph above, Patton is in Italy using a riding crop to point towards an objective he wanted captured. On the right, he stands as not only a tank commander but also as the first great American champion of tank warfare. (LOC.)

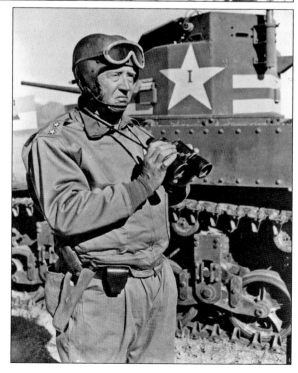

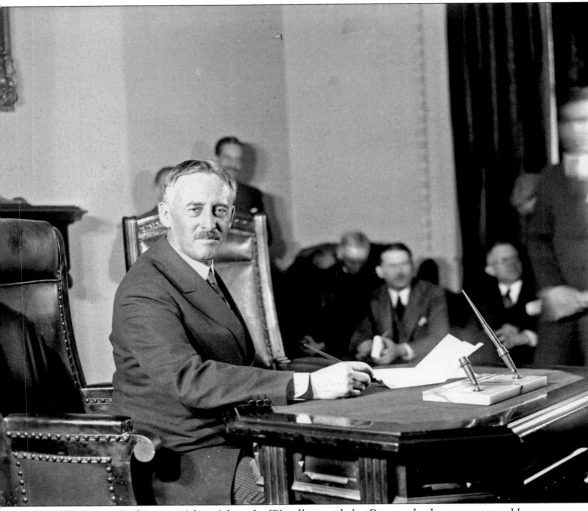

In 1929, Henry L. Stimson (above) bought Woodley, and the Pattons had to move out. Henry Stimson was one of those exceptionally rare American statesmen admired on both sides of the aisle. He served in the cabinets of two Republican and two Democratic presidents. His service to his country spanned the years from the Spanish-American War through World War II. Respect for him was so great that 12 years after his death, at the time of the Cuban Missile Crisis, the Kennedy people were still asking themselves, "What would Henry Stimson do?" (LOC.)

The first president to be impressed by Henry Stimson was Theodore Roosevelt (right). It happened in Rock Creek Park when Roosevelt and his secretary of war, Elihu Root, were walking on one side of the surging creek (below) while Stimson was riding on the other. Elihu Root, who had previously been Stimson's boss in a New York law firm, yelled in jest across the creek, "The president of the United States directs Sergeant Stimson of Squadron A [in reference to Stimson's service at the time of the Spanish-American War] to cross the creek and come to his assistance by order of the Secretary of War." Stimson took Root entirely seriously and galloped his horse into the creek. To Root's horror, horse and rider were swept downstream. However, after a few breathless moments, both Stimson and his horse managed to gain footing and struggle to the near shore. Stimson then rode up to Roosevelt, saluted, and said, "Ready for duty." Roosevelt's reactions to this extraordinary feat of horsemanship and bravado were to first advise Stimson to "hurry home and drink all the whiskey you can!" and then, in 1906, to appoint him U.S. Attorney for the Southern District of New York. (LOC.)

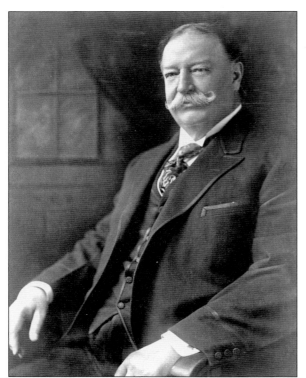

After an extraordinarily distinguished five-year tenure as U.S. attorney, Stimson was appointed secretary of war by Roosevelt's successor, Pres. William Howard Taft (above). During those years in the War Department, Stimson attempted to streamline the military, which involved shortening enlistments, increasing time in the reserves, and reaching out to a broader cross section of the population. With respect to territories won in the Spanish-American War, he was a Darwinian who believed it was the right and duty of the United States to rule and civilize the "childlike" populations until they were capable of ruling themselves. (LOC.)

When the United States entered World War I, 49-year-old Henry Stimson enlisted in the army and eventually reached the rank of lieutenant colonel. He saw the war as a struggle in which democracy and civilization itself were at stake, and he wanted to fight as a soldier for those ideals. In July 1918, he was transferred to a unit on the front line in France, but the war ended before he saw combat. (LOC.)

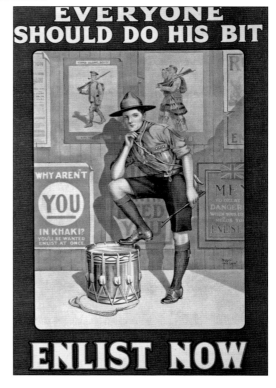

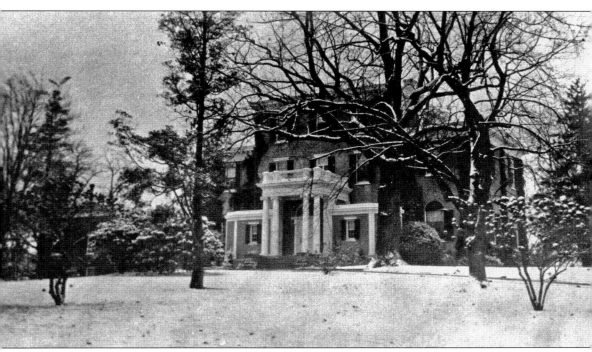

It was Pres. Herbert Hoover who would finally bring Henry and Mabel Stimson to Woodley. It happened in 1929, when Hoover appointed Henry Stimson secretary of state. At that time, Woodley was still generally regarded as "Washington's greatest manor." Stimson described the house as "comfortable and spacious." The grounds covered 18 acres, and "the view across Rock Creek Valley to the center of the city was peaceful and consoling to [us] both." Note that the two additions on either side of the portico were added at this time as cloakrooms. (Maret School Archives.)

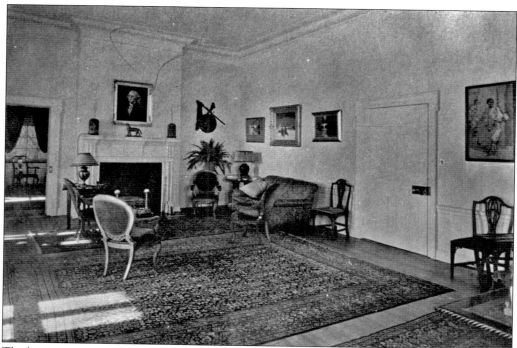

The living room at Woodley during Stimson's tenure was a relatively informal, sparsely furnished room that could therefore accommodate a crush of people. (Maret School Archives.)

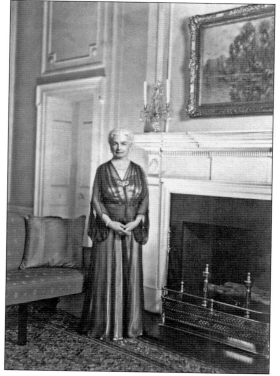

Mabel Stimson stands in front of the fireplace in the parlor. The landscape over the mantelpiece was painted by Jean-Baptiste-Camille Corot, who in the 1920s was among the most sought after of all artists. (Henry Lewis Stimson Papers, Manuscripts and Archives, Stirling Library, Yale University.)

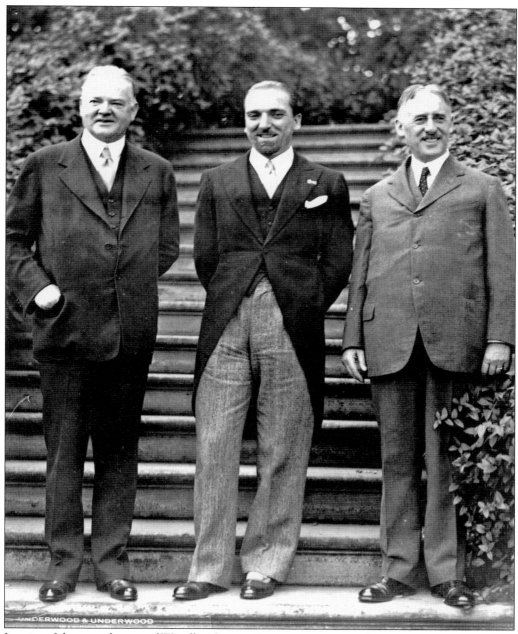

In spite of the consolations of Woodley, Stimson's years as secretary of state were perhaps the most frustrating of his career. Hoover was an isolationist. Stimson was an internationalist. In both Germany and Japan, militant factions were gaining more and more power. After 1929 came the Depression. This photograph, in which Stimson and Hoover flank Italian foreign minister Dino Grandi, belies the tension that existed between the two men. (LOC.)

The climax of the tension came in October, 1931. Stimson had been arguing that the United States should forgive the English and the French the debts they had accumulated during World War I. Hoover, a fiscal conservative, resisted. Finally, in desperation, Stimson sent his aide, Harvey Bundy, to the White House to tell the president that if there was not at least a moratorium placed on the debts, Stimson, the most respected statesman of his day, would resign. At long last, Hoover relented. He told Bundy he would agree to a moratorium. When Bundy returned to Woodley, teetotaler Stimson marched down into the basement of the house, returned with a long-secreted bottle of Scotch, poured two glasses, and then, ignoring Prohibition and his own customary abstinence, drank a celebratory toast to his victory over the president. (iStockphoto.)

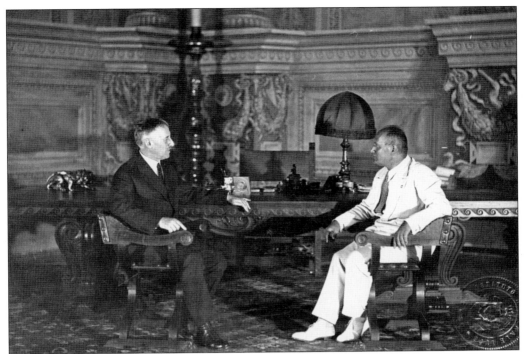

The year 1931 was also when Stimson took a much-publicized tour of Europe. One of the European leaders with whom he met was Benito Mussolini, seen here in animated conversation with Stimson. It was at that meeting that Stimson made both an emphatic pitch for disarmament and a dire warning that "either Europe will change or go in the cycle of competition and war." (Henry Lewis Stimson Papers, Manuscripts and Archives, Stirling Library, Yale University.)

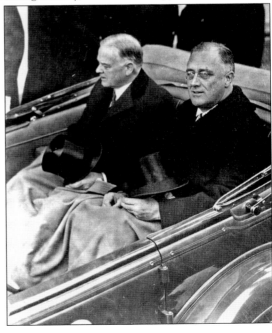

In 1932, Franklin Roosevelt defeated Herbert Hoover in the presidential election. This photograph, taken during the inaugural parade, captures a degree of the glumness of Hoover (left) and the ebullience of Roosevelt. For Stimson, the election signaled the end of his career in public service, or so he thought. Meanwhile, the nation was sunk into the depths of the Depression, and five ominous weeks earlier, Adolf Hitler had been elected chancellor of Germany. (LOC.)

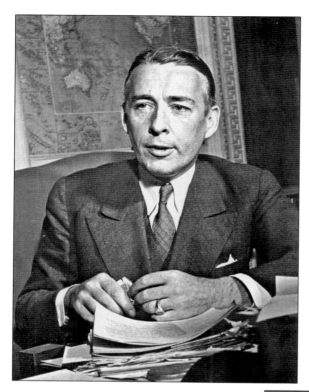

Between 1933 and 1940, Henry Stimson enjoyed what turned out to be a temporary retirement. Although he retained Woodley, the bulk of those years was spent at Highhold, his estate on Long Island. In 1939, he leased Woodley to Adolf Berle (left) and his wife, Beatrice. At the time, Berle was assistant secretary of state and one of the architects of the New Deal. The Berles continued to keep Woodley on the society pages due to the prominence of the guests at their dinners and garden parties. One of those guests was Albert Einstein (below). (LOC.)

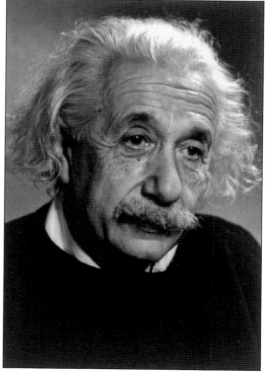

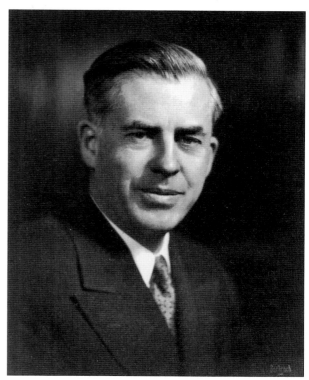

Vice president Henry Wallace (right) frequently came to play tennis on the Woodley tennis court. He also tended a "victory garden" next door on land that was owned by the Swiss delegation. Another regular visitor was Cordell Hull, secretary of state (below). He came to play croquet, because, at that time, Woodley had the best croquet lawn in Washington. According to one frequently quoted source, Hull was fond of bashing an opponent's ball into the bushes beyond the course with the words "Take that, Hitler!" or "Take that, Mussolini!" (LOC.)

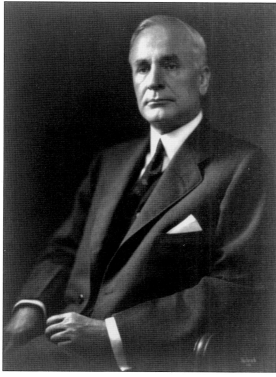

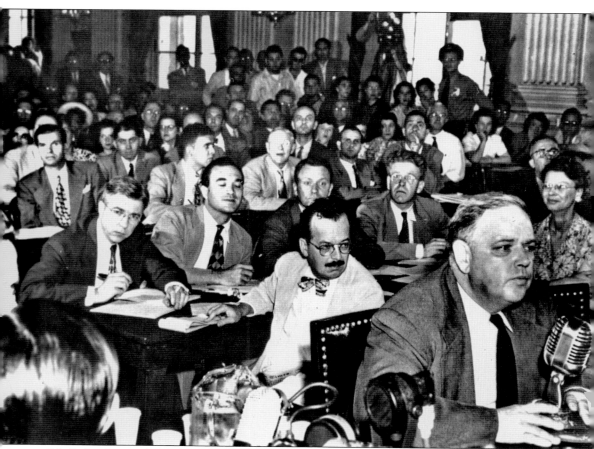

Of all the dinners hosted by the Berles, perhaps the most important was held on September 2, 1939, the day after World War II began in Europe. It was at that dinner that Whittaker Chambers, a former Communist agent as well as a star journalist for *Time* magazine, sat in the Woodley dining room and indicated the degree of Communist infiltration into the State Department, specifically implicating Alger Hiss, a darling of the Liberal Establishment. That accusation was going to culminate in the showcase trial of Hiss in 1949. In the photograph above, Chambers is giving testimony to the House Un-American Activities Committee. Alger Hiss is the handsome man in the left center behind the press table. (LOC.)

By July 1940, France had fallen to the Germans, and Britain was in dire peril. Nevertheless, American public opinion was against American involvement. To shore up national resolve, Franklin Roosevelt appointed 73-year-old Henry Stimson to be secretary of war. As a result, Stimson needed to reestablish himself in Woodley immediately. Stimson's letter to Adolf Berle (right) is a thank-you note for agreeing to vacate Woodley on very short notice. Berle's letter (below) is a slightly miffed response. (Henry Lewis Stimson Papers, Manuscripts and Archives, Stirling Library, Yale University.)

THIRTY-TWO LIBERTY STREET
NEW YORK

July 8, 1940.

Mr. A. A. Berle, Jr.,
Department of State,
Washington, D. C.

My dear Mr. Berle:

We received Mrs. Berle's telegram in which she said she would turn over Woodley to us this morning and I am very grateful to both you and her for your kindness in doing this so promptly and in such kind spirit. I hope that I may have many opportunities of seeing you both during the coming months.

I enclose my check for $433.33 as the proportionate amount of the rent of Woodley from July 8th to the 20th which is due to you as a rebate.

With many thanks, I am

Very sincerely yours,

Henry L. Stimson

(Personal)

My dear Mr. Secretary:

Let me thank you for your letter of July 8th enclosing check for $433.33, being the adjustment on the rent at Woodley. Both Mrs. Berle and I were only too glad to have been able to meet your convenience in the matter. I think we should have been glad to have another day to finish one or two odd jobs, but we gathered that you preferred immediate possession.

Since we are planning to set up a domicile immediately next door, I hope we shall have the pleasure of seeing you from time to time.

With kind regards, I am

Sincerely yours,

The Honorable
Henry L. Stimson,
3000 Cathedral Avenue,
Washington, D. C.

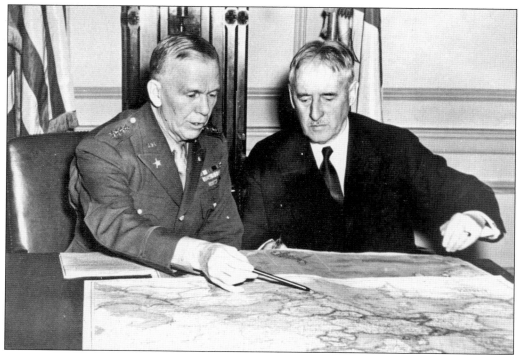

As the new secretary of war, Stimson bore the responsibility of ratcheting up American preparedness. First order of business was to institute a peacetime draft. In the photograph above, Stimson is shown with army chief of staff George Marshall. It was at Woodley that these two men met and worked out the details of what became the Burke-Wadsworth Act, whereby millions of young Americans were called to service. The photograph on the left shows Henry Stimson meeting with the House Foreign Affairs Committee and making the case for the Lend Lease Bill, which would allow the United States to ship armaments in whatever quantities to those nations deemed "vital to the defense of the United States." Once passed, the Lend Lease Act saved the British from sure defeat. (LOC.)

Pictured above is Henry Stimson's study. Below, Henry Stimson (with his back to us) is in conference in his study. The gentleman to the right of the lamp is Pierre Laval, former prime minister of France, who was then prime minister of the Vichy government, which was busy collaborating with the Nazis. After the war ended, Laval was executed by a firing squad for high treason. (Henry Lewis Stimson Papers, Manuscripts and Archives, Stirling Library, Yale University.)

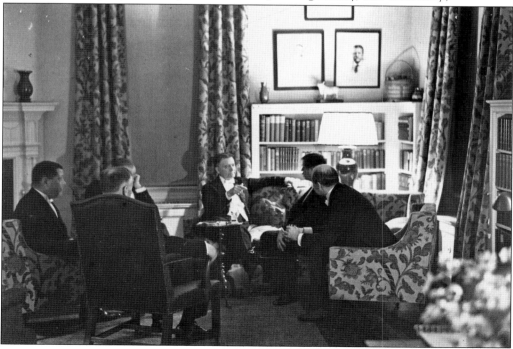

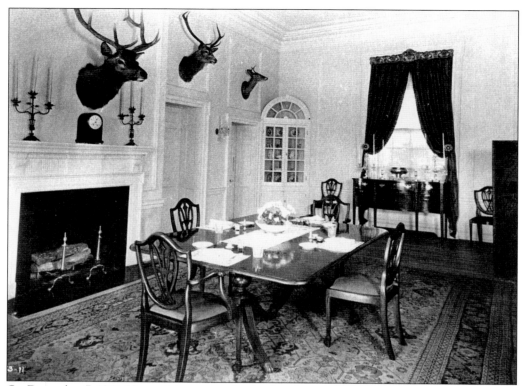

On December 7, 1941, Henry Stimson was having lunch in the Woodley dining room when Pres. Franklin Roosevelt telephoned to announce that Pearl Harbor had just been bombed. Within 24 hours, the United States would be at war with both Japan and Germany. (LOC.)

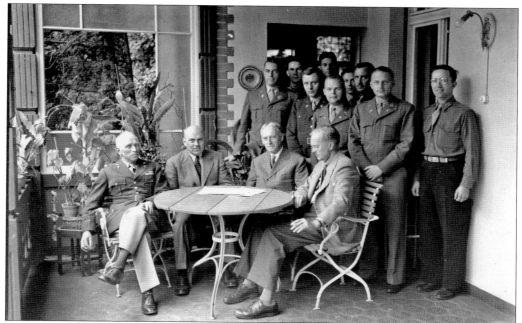

It was at the last conference of the Grand Alliance at Potsdam, Germany, in July 1945 that the end of the war was projected and defined. Pres. Harry Truman—who had recently replaced Roosevelt—Winston Churchill, and Joseph Stalin issued a joint demand of unconditional surrender to the Japanese. While the conference was in progress, Truman received word, through Stimson, that there had been a successful detonation of the atomic bomb at Alamogordo, New Mexico. It was also at Potsdam where a directive, approved by President Truman and issued by Woodley resident Henry Stimson, authorized the dropping of an atomic bomb on Japan as soon as August 3, weather permitting. In this photograph taken at Potsdam, there are two Woodley residents. Seated third from the left is Henry Stimson. Seated on the extreme left is George Patton "Old Blood and Guts" himself, in a uniform tailor-made by Brooks Brothers. (Henry Lewis Stimson Papers, Manuscripts and Archives, Stirling Library, Yale University.)

In August 1945, atomic bombs were dropped on Hiroshima and Nagasaki. Stimson subsequently wrote the following about the decision to drop the bombs: "No man, in our position and subject of our responsibilities, holding in his hands a weapon of such possibilities for (ending the war) and saving those lives, could have failed to use it and afterwards looked his countrymen in the face." After the Japanese surrendered, Henry Stimson saw his role as over. On September 21, 1945, at age 78, he retired once again from government service, this time for good. In the following year, with extreme reluctance, Henry Lewis Simson gave his beloved Woodley to Philips Andover Academy, his high school alma mater, and Woodley passed out of private hands. (LOC.)

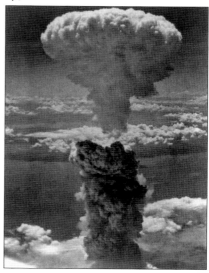

On October 20, 1950, Henry and Mabel Stimson left Highhold, Stimson's estate on Long Island, and went for a drive in the countryside to enjoy the fall foliage. He was suddenly stricken by pain. The driver turned around and drove back to Highhold. Later that day, Stimson died quietly with ever-devoted Mabel at his side. Thus was the passing of Henry Stimson, a man who was lionized on both sides of the aisle, and who, with the exception of the two Roosevelts and Woodrow Wilson, did more to shape American foreign policy than any other figure in the first half of the 20th century. And for the 17 most important years of his extraordinary life, his career revolved around Woodley. (Henry Lewis Stimson Papers, Manuscripts and Archives, Stirling Library, Yale University.)

EPILOGUE

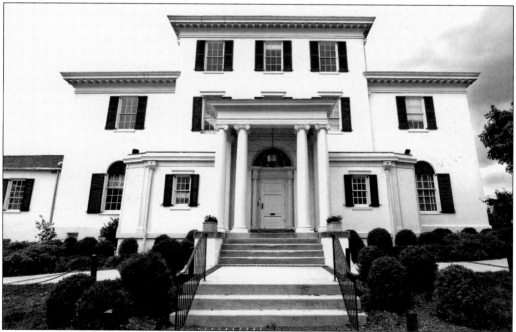

In 1950, Woodley was purchased by Maret School. It now houses the Maret library and administrative offices. The facade (above) still commands the top of the hill, but the balustrade above the portico was removed years ago, and the building is now painted white. (Photograph by Charles Fishl.)

Although the building has been transformed from a house into a school, a few original elements remain. Here in the Maret library, above the original 1801 mantelpiece, hangs the original early-19th-century portrait of Ann Plater Key. (Photograph by Charles Fishl.)

"And so we beat on, boats against the current, borne back ceaselessly into the past." So ends *The Great Gatsby*, written by F. Scott Fitzgerald, who venerated his direct ancestor, Philip Barton Key, the man who built Woodley. (LOC.)

BIBLIOGRAPHY

Berlin, Ira. *Many Thousands Gone: The First Two Centuries of Slavery in North America.* Cambridge: Harvard University Press, 1998.

Beschloss, Michael R. *The Conquerors: Roosevelt, Truman, and the Destruction of Hitler's Germany.* New York: Simon and Schuster, 2002.

Brinkley, Alan. *American History: A Survey.* New York: McGraw-Hill, Inc., 2005.

Clark-Lewis, Elizabeth ed. *First Freed: Washington, D. C. in the Emancipation Era.* Washington: Howard University Press, 2002.

Cornish, Dudley Taylor. *The Sable Arm: Black Troops in the Union Army, 1861–1865.* Kansas: University Press of Kansas, 1987.

Elfin, Margery L., Paul K. Williams and the Forest Hills Neighborhood Alliance. *Forest Hills.* Charleston: Arcadia Publishing, 2006.

Farquhar, Arthur and Samuel Crowther. *The First Million the Hardest.* Whitefish, MT: Kessinger Publishing, 2006.

Foote, Shelby. *The Civil War: A Narrative.* New York: Random House:, 1963.

Hodgson, Godfrey. *The Colonel: The Life and Wars of Henry Stimson, 1867–1950.* Boston: Northeastern University Press, 1990.

Isaacson, Walter and Evan Thomas. *The Wise Men.* New York: Simon and Schuster, 1986.

Jones, Caleb. *Orderly Book of the Maryland Loyalists Regiment.* Brooklyn: Historical Printing Club, 1891.

Lesco, Kathleen M. et al. *Black Georgetown Remembered: A History of Its Black Community From the Founding of "The Town of George" in 1751 to the Present Day.* Washington: Georgetown University Press, 1991.

Levey, Bob and Jane Freundel, *Washington Album: A Pictorial History of the Nation's Capital.* Washington: Washington Post Books, 2000.

Lynch, Denis Tilden. *Grover Cleveland: A Man Four-Square.* Horace Liveright, Inc., 1932.

McPherson, James M. *The Negroes Civil War: How American Blacks Felt and Acted during the War for the Union.* New York: Random House, 1993.

Makley, Michael. *The Infamous King of the Comstock: William Sharon and the Gilded Age in the West.* Reno & Las Vegas: University of Nevada Press, 2006.

Mann-Kenney, Louise. *Rosedale: the Eighteenth Century Country Estate of General Uriah Forrest, Cleveland Park, Washington, D.C.* Washington: Louise Mann-Kenney, 1989.

Niven, John. *Martin Van Buren: the Romantic Age of American Politics.* New York: Oxford University Press, 1983.

Phillips, William. *Ventures in Diplomacy*. Boston: Beacon Press, 1952.

Pitch, Anthony S. *The Burning of Washington: The British Invasion of 1814*. Annapolis: Naval Institute Press, 1998.

Potter, Stephen R. *Commoners, Tribute, and Chiefs: the Development of Algonquian Culture in the Potomac Valley*. Charlottesville and London: University Press of Virginia, 1994.

Rehnquist, William H. *Grand Inquests: The Historic Impeachments of Justice Samuel Chase and President Andrew Johnson*. New York: William Morris and Company, 1999.

Reps, John W. *Washington on View: The Nation's Capital Since 1790*. Chapel Hill and London: The University of North Carolina Press, 1991.

Shenton, James P. *Robert John Walker: A Politician from Jackson to Lincoln*. New York: Columbia University Press, 1961.

Smith, Page. *Trial by Fire: A People's History of the Civil War and Reconstruction*. New York: McGraw-Hill, 1982.

Stimson, Henry and McGeorge Bundy. *On Active Service in Peace and War*. New York: Harper and Brothers, 1947.

Weybright, Victor. *Spangled Banner: The Story of Francis Scott Key*. New York: Farrar & Rinehart, 1935.

INDEX

ACROSS AMERICA, PEOPLE ARE DISCOVERING SOMETHING WONDERFUL. *THEIR HERITAGE.*

Arcadia Publishing is the leading local history publisher in the United States. With more than 4,000 titles in print and hundreds of new titles released every year, Arcadia has extensive specialized experience chronicling the history of communities and celebrating America's hidden stories, bringing to life the people, places, and events from the past. To discover the history of other communities across the nation, please visit:

www.arcadiapublishing.com

Customized search tools allow you to find regional history books about the town where you grew up, the cities where your friends and family live, the town where your parents met, or even that retirement spot you've been dreaming about.